Travel Between the Lines

Adult Coloring Book

Inspirational Coloring for Globetrotters and Daydreamers

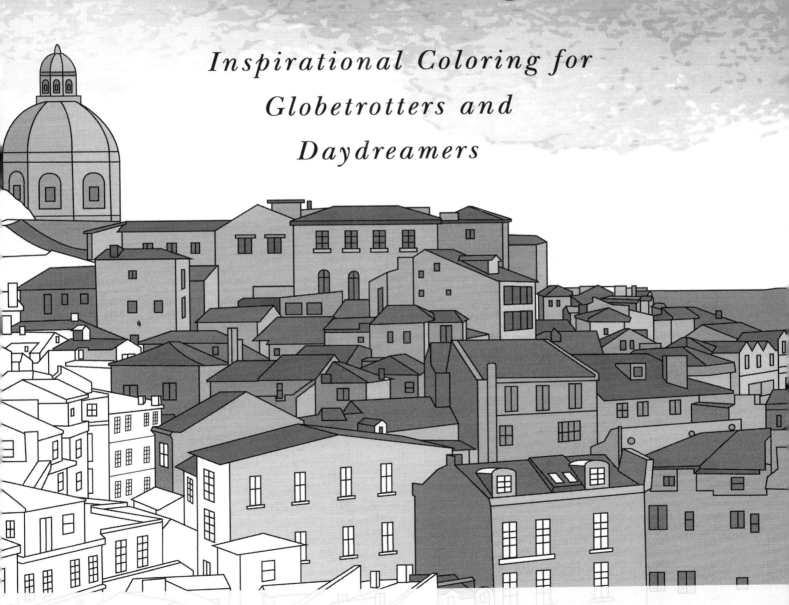

Wandertooth Media

ISBN#: 0-9949731-0-1
ISBN 13#: 978-0-9949731-0-8

Wandertooth Media is the brainchild of Geoff and Katie Matthews, permanent travelers on the road since 2013, with more than 50 countries visited together.

A wandertooth is a noun – you know, like a person, place, or thing. In this case, it's a thing. Like a sweet tooth, only with *travely* goodness instead of sugary goodness. It's a fondness or desire for wandering or travel; an unquenchable desire; a craving that — once satisfied — only leaves you salivating and desperate for more.

The illustrations in this book are based on Geoff and Katie's photographs during their travels, and in one case, a friend's photo used with permission, and credited in the List of Illustrations. The copyright © for this book belongs to Wandertooth Media Inc. as of 2015, and all rights are reserved.

Travel Between the Lines...
and Online

Show us your creations, read about a colorful destination at wandertooth.com, or buy a ticket and inspire us with your adventures

Instagram
@wandertooth

Facebook
facebook.com/wandertooth

Twitter
@wandertooth

Pinterest
pinterest.com/wandertooth

wandertooth.com

#travelbetweenthelines

The Birth of an Idea

The idea to publish a travel-themed adult coloring book came to us when we were in Oaxaca, Mexico (pronounced: *wa-ha-ka*), a relatively small state capital in Mexico's southwest that is shaped by the traditions of the 16 recognized indigenous groups living in the state. Oaxaca is bursting with color – architecture, clothing, textiles, festivals and food – and temporarily living here awoke Katie's long-held desire to illustrate scenes of our travels, despite having next to no talent as an illustrator. Using our travel photographs as a base to create digital illustrations, and sharing them with others, seemed like a perfect solution.

As we went through the motions of actually making this adult coloring book, our dreams for it grew. We'd been travelling permanently for 2 years, with many shorter trips and stints as expatriates before that, and had learned from experience that some of the least visited places – countries like Romania and Taiwan – sometimes offer the most rewarding experiences. We wanted to share that with others in a new and unexpected way.

Tell us what you think at hello@wandertooth.com, and we promise we'll get back to you.

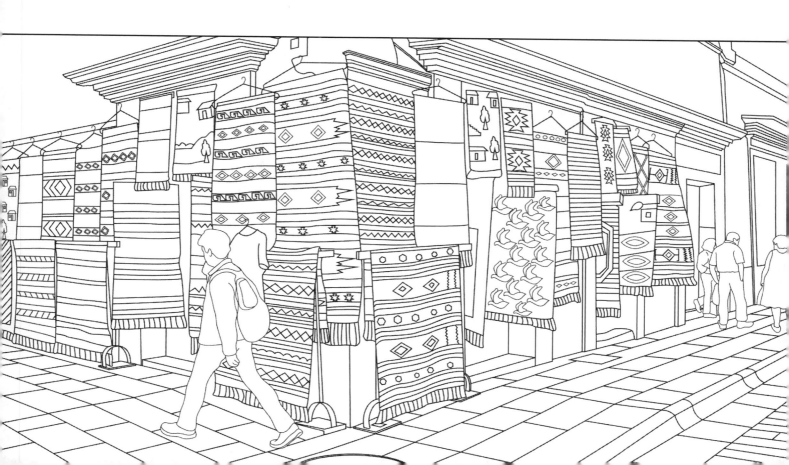

Travel Between the Lines: Here's How

Select an illustration to color at random, or refer to the *Table of Contents* to find a favorite destination. If you want to know more about the picture, refer to our *List of Illustrations* at the back of the book.

Grab your favorite coloring tools. We like high-quality, fine-tip felts for the nitty-gritty details, and pencil crayons for wide-open spaces, but we like experimentation and imagination even more!

Color until you're finished, or you don't want to color anymore. Some of the illustrations can be completed in one session, and others might take longer.

Cut out your finished work and post it on your fridge, in your office, or somewhere you look often to continue traveling between the lines.

Table of Contents

Lisbon, Portugal ... 9

Buenos Aires, Argentina ... 11

Cartagena, Colombia ... 13

Paris, France .. 15

Riga, Latvia ... 17

Shandong Province, China ... 19

Barichara, Colombia ... 21

Budapest, Hungary .. 23

Mount Tai, China ... 25

Granada, Spain .. 27

Cijin Island, Kaohsiung, Taiwan .. 29

Vilnius, Lithuania .. 31

La Boca, Buenos Aires, Argentina .. 33

Xiao Liu Qiu Island, Taiwan ... 35

Kotor, Montenegro .. 37

Strasbourg, France .. 39

Berlin, Germany .. 41

Hong Kong ... 43

Havana, Cuba .. 45

La Paz, Bolivia .. 47

Mekong Delta, Vietnam .. 49

Prague, Czech Republic .. 51

Kraków, Poland ... 53

La Boca, Buenos Aires, Argentina .. 55

Sibiu, Romania .. 57

Cijin Island, Kaohsiung, Taiwan .. 59

Milan, Italy .. 61

Fo Guang Shan Monastery, Taiwan .. 63

Lisbon, Portugal .. 65

Quito, Ecuador .. 67

Antigua, Guatemala ... 69

Seville, Spain ... 71

Tartu, Estonia .. 73

Oaxaca de Juárez, Mexico ... 75

Porto, Portugal .. 77

Kaohsiung, Taiwan .. 79

Wrocław, Poland .. 81

Portland, Oregon, USA .. 83

Versailles, France .. 85

Lisbon, Portugal .. 87

Kyoto, Japan .. 89

Tallinn, Estonia ... 91

Strasbourg, France .. 93

Rajasthan State, India ... 95

Amsterdam, Netherlands ... 97

Melaka, Malaysia .. 99

Glasgow, Scotland ... 101

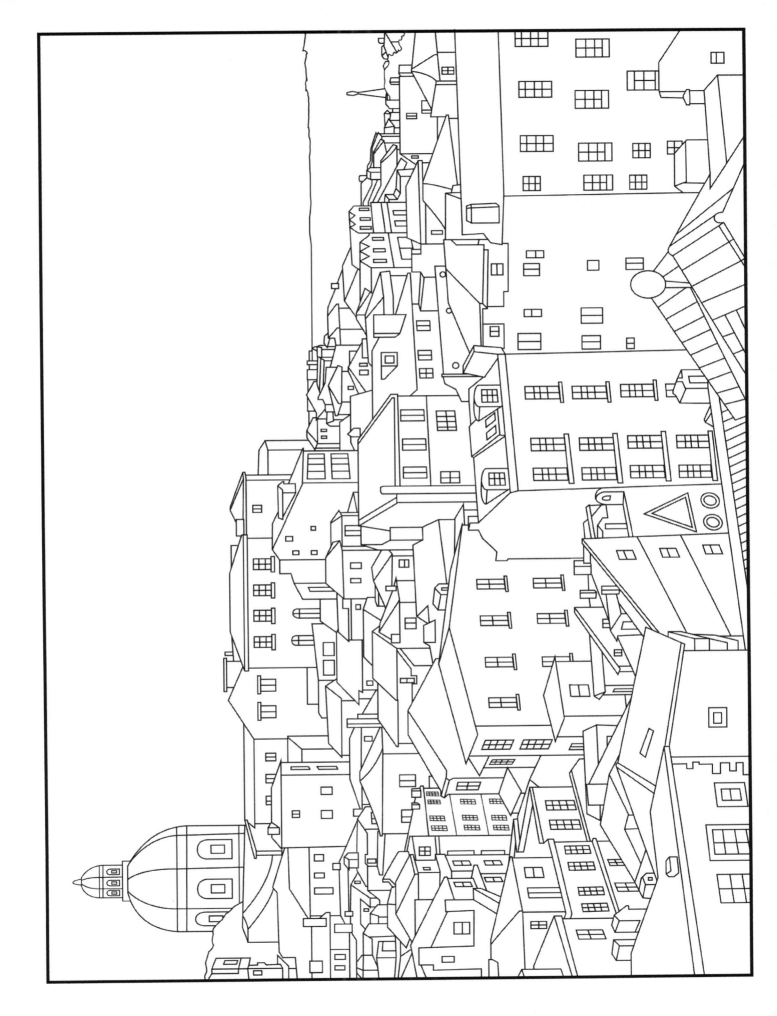

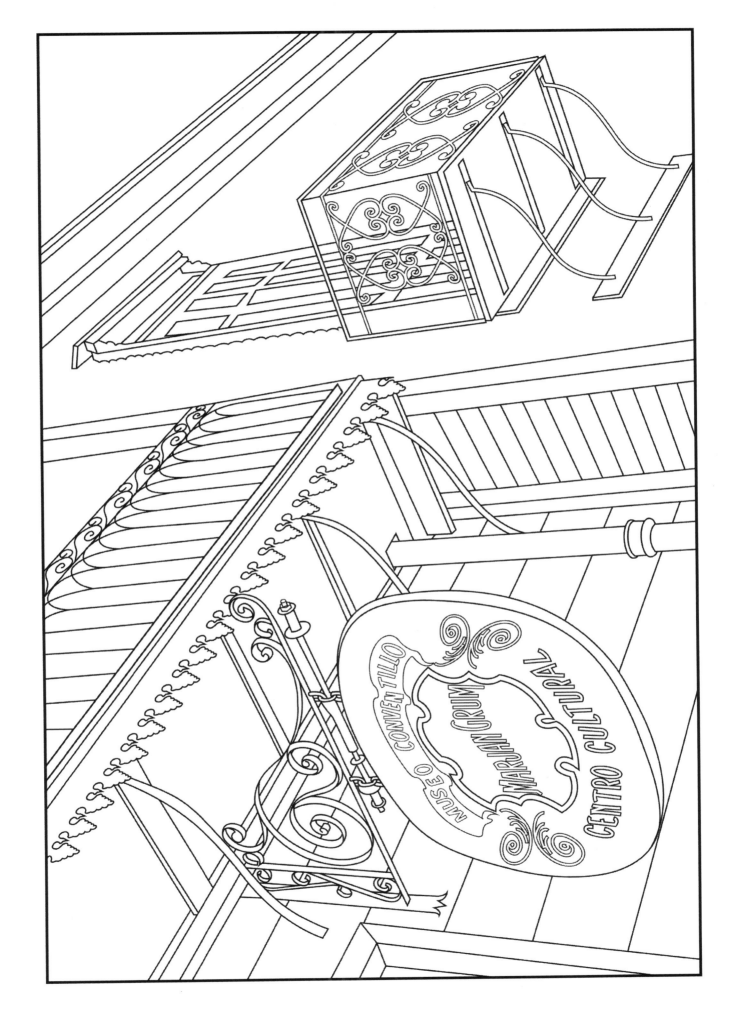

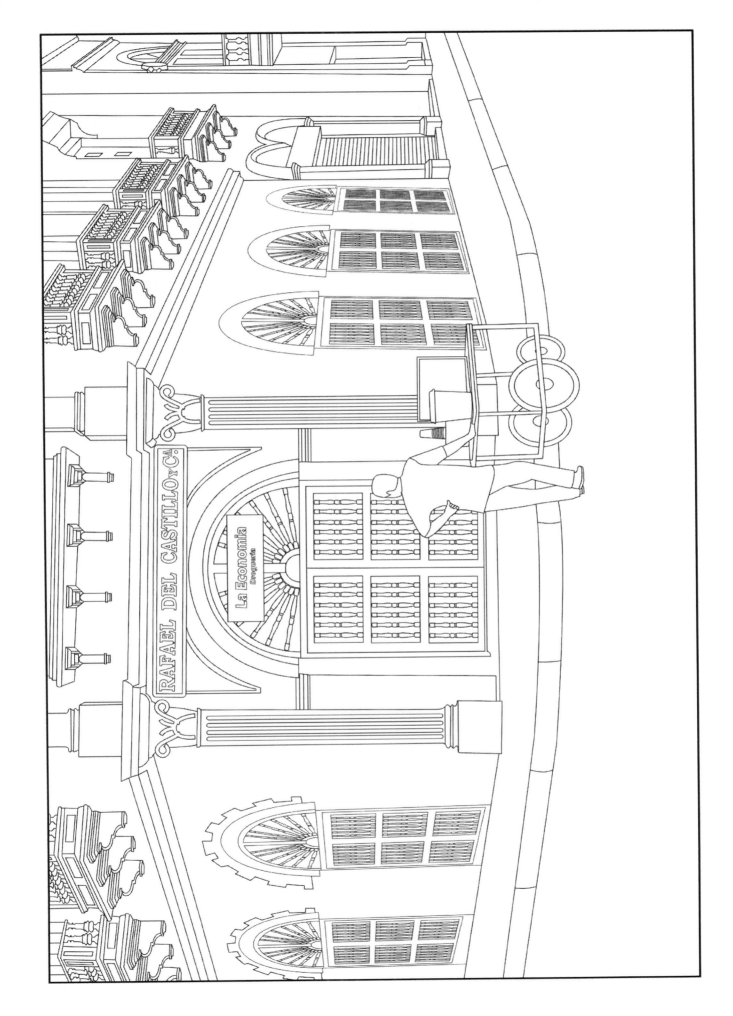

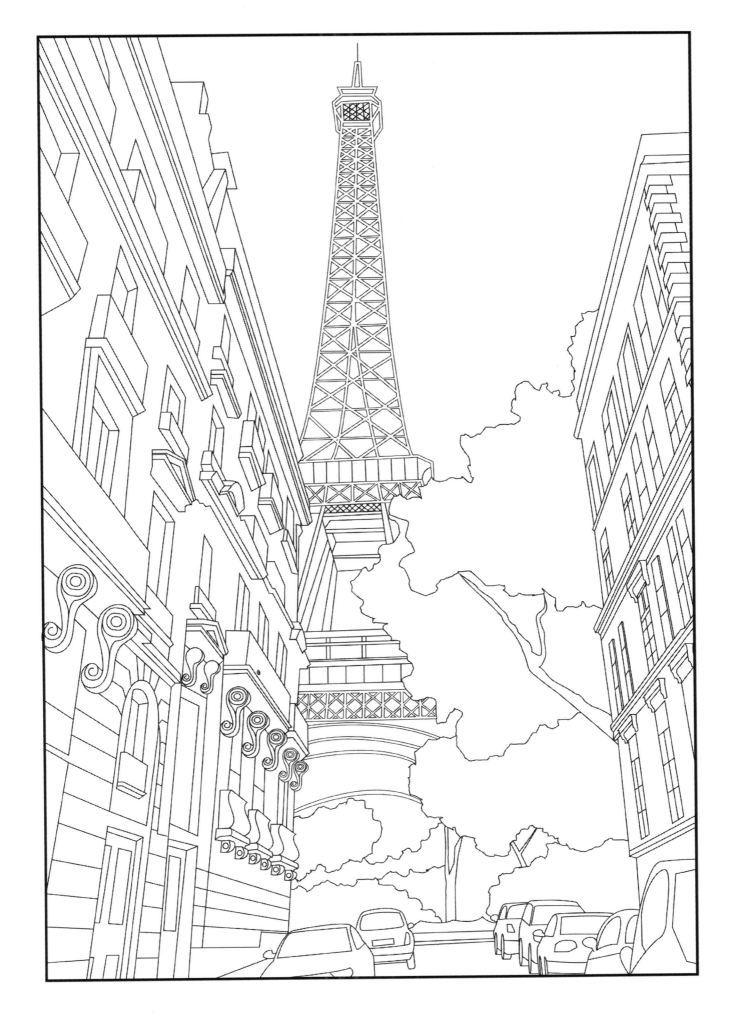

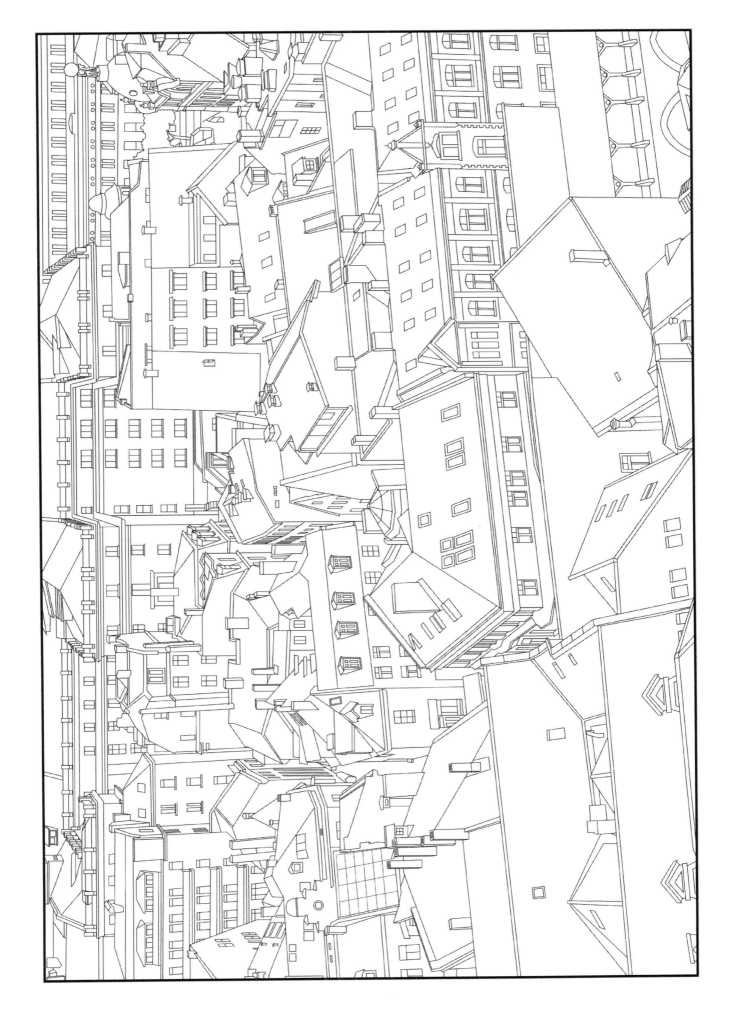

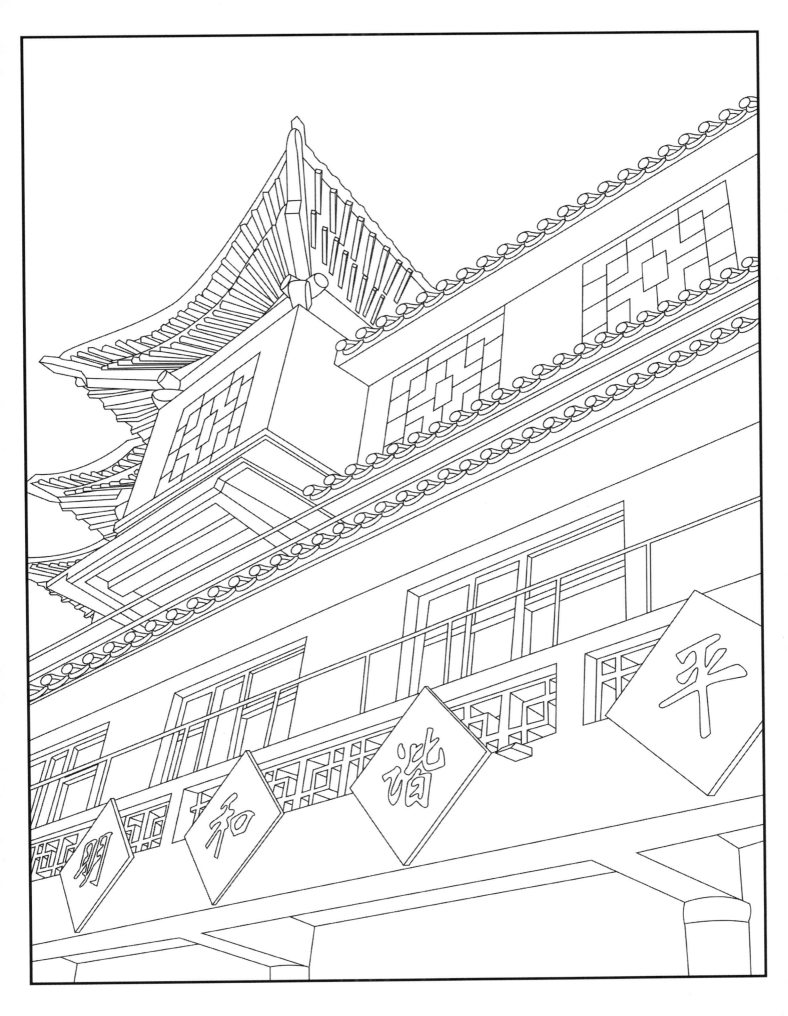

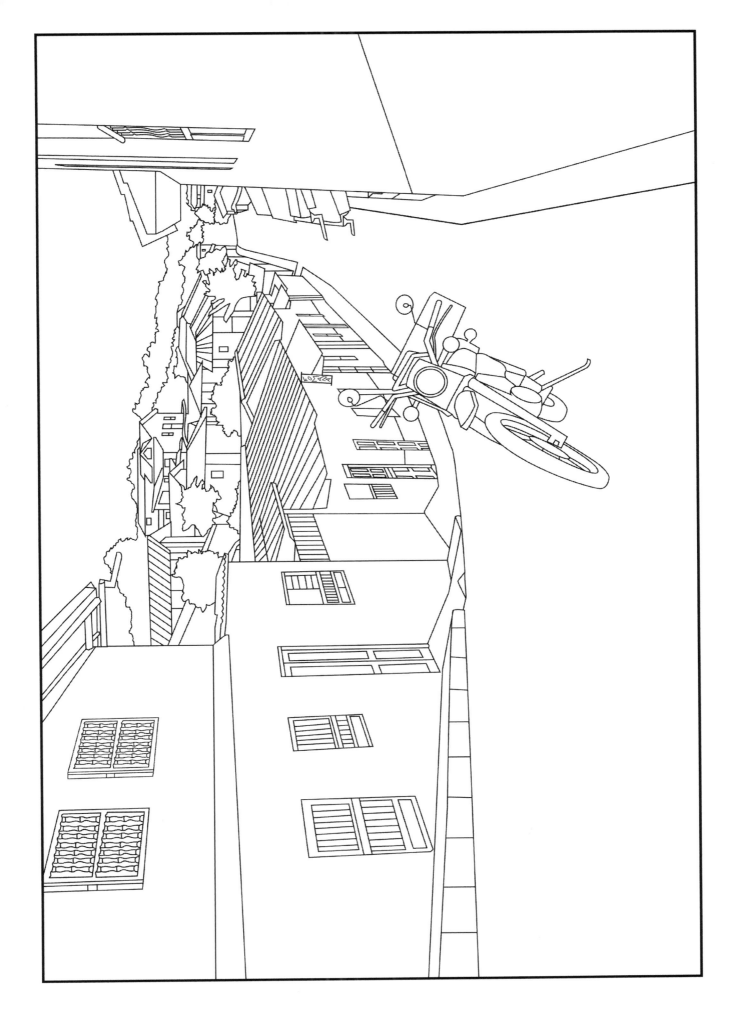

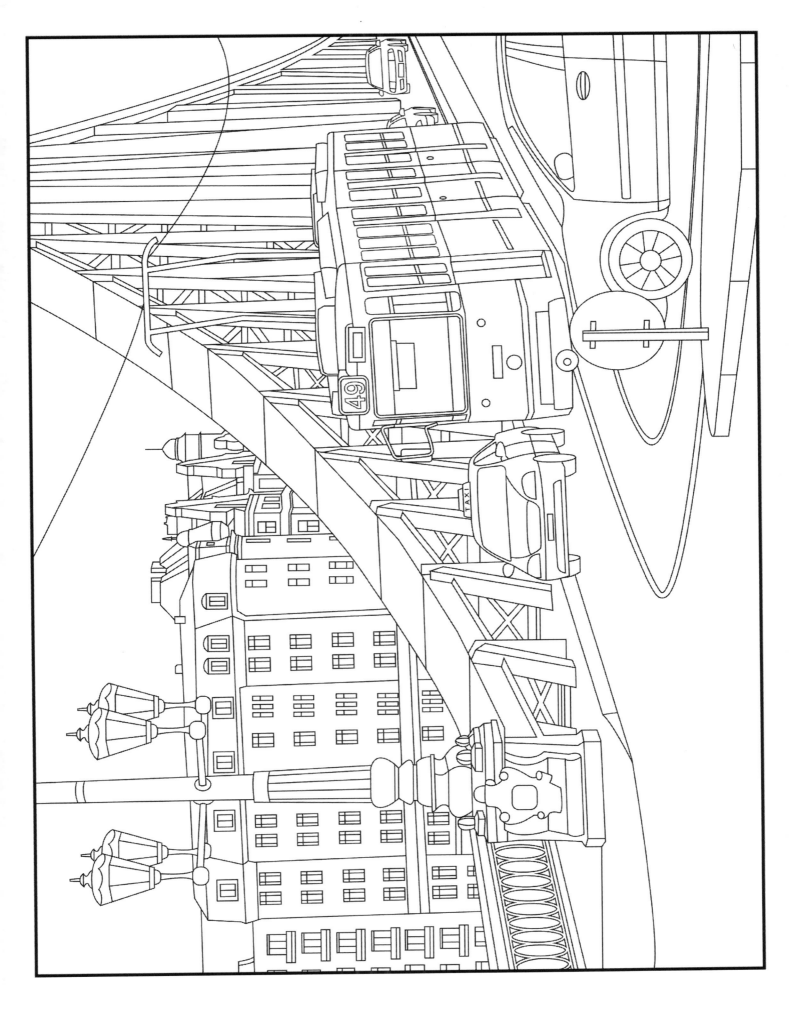

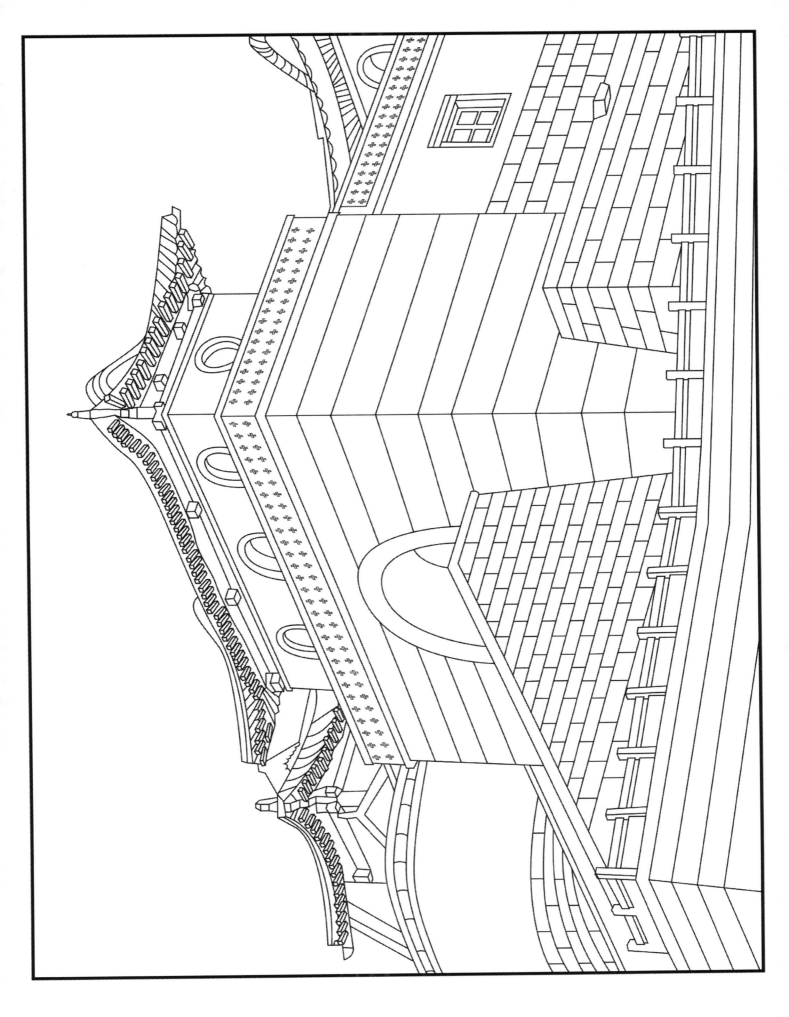

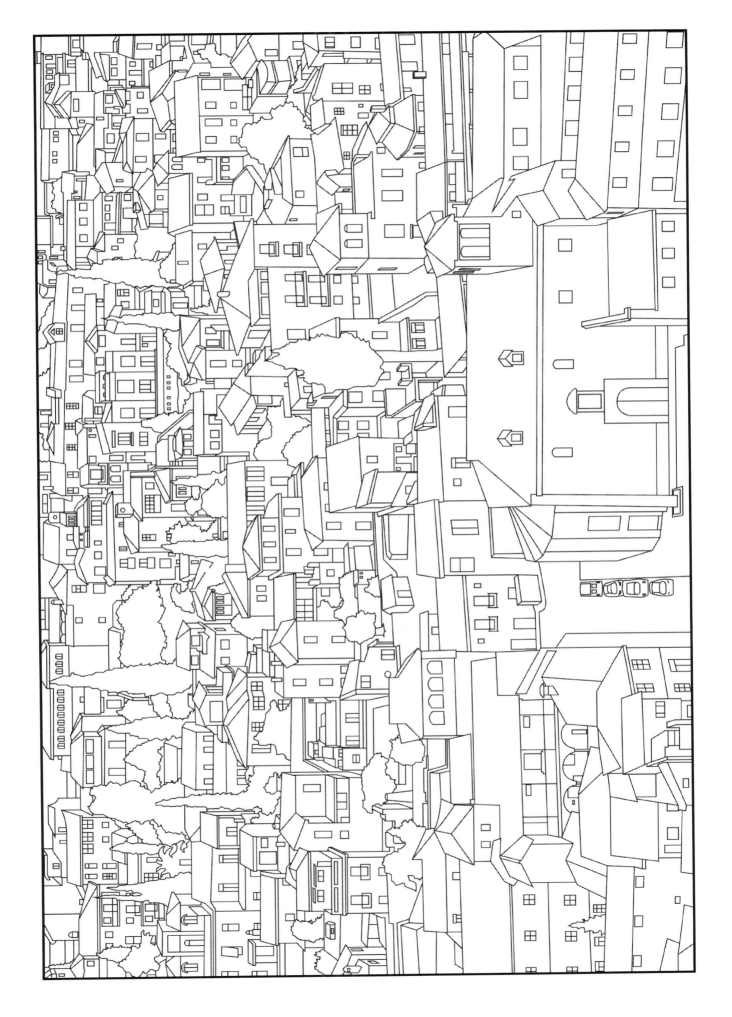

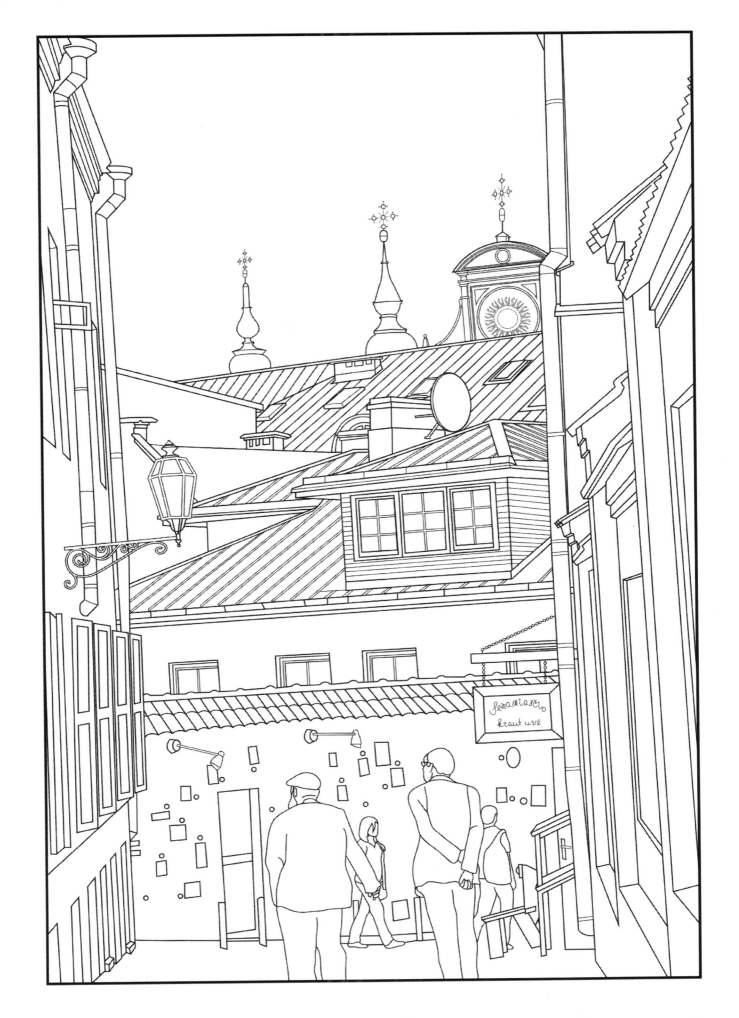

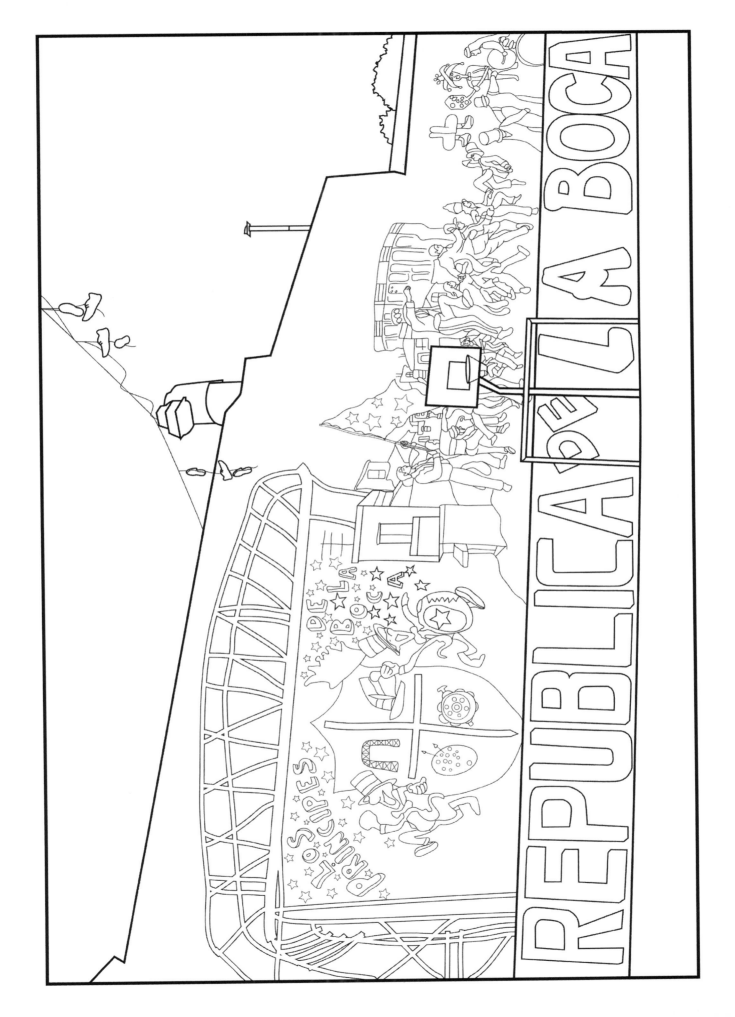

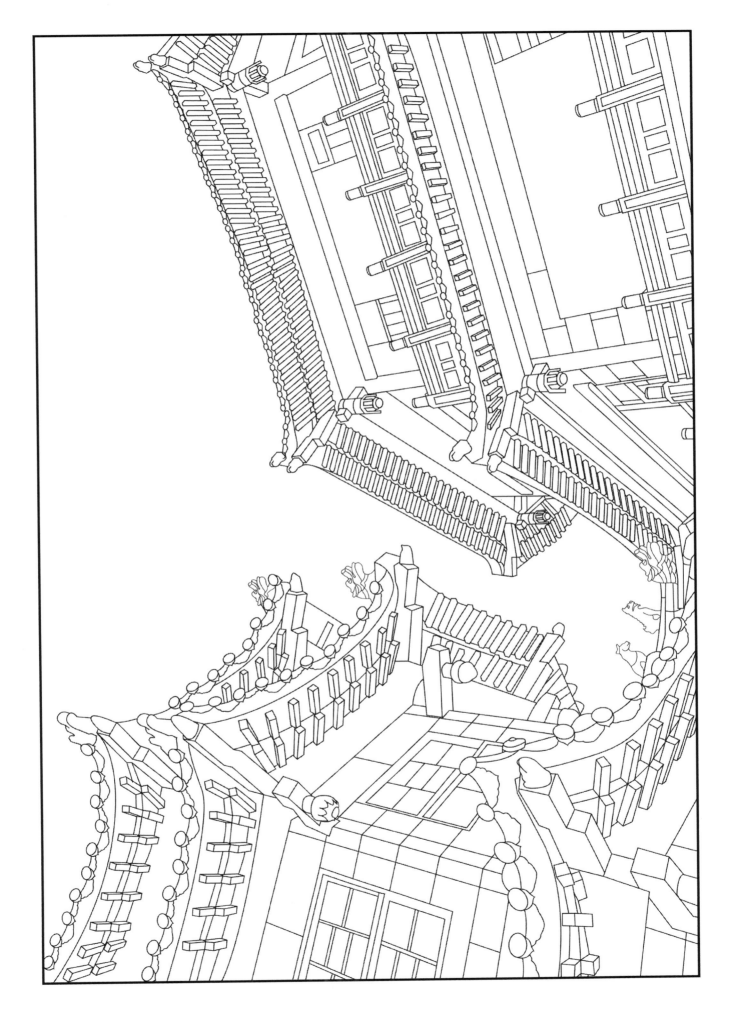

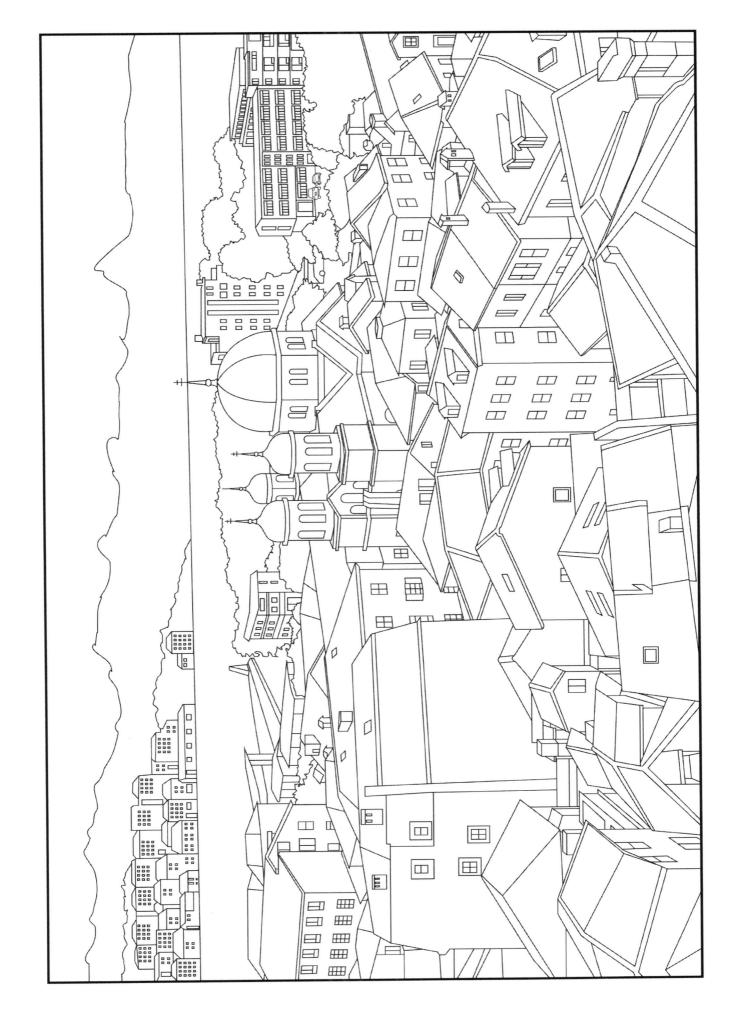

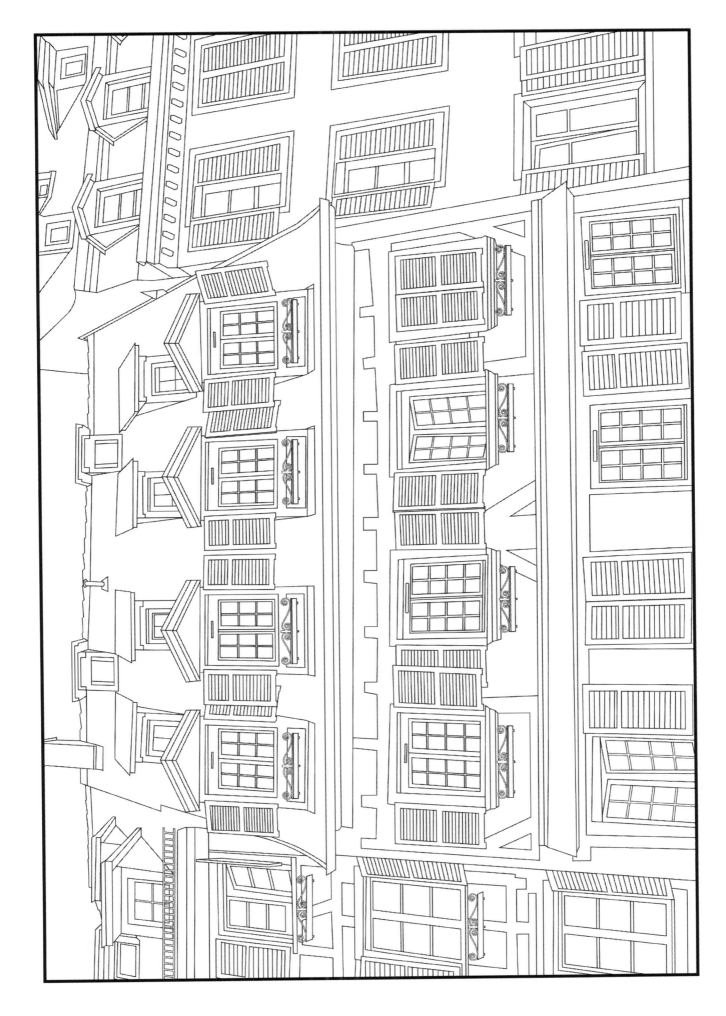

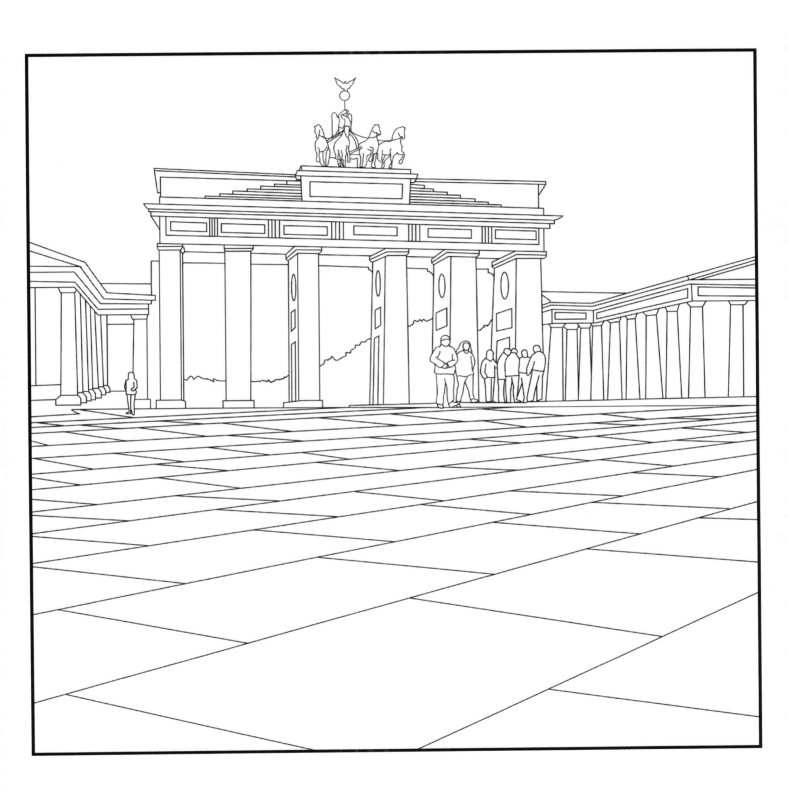

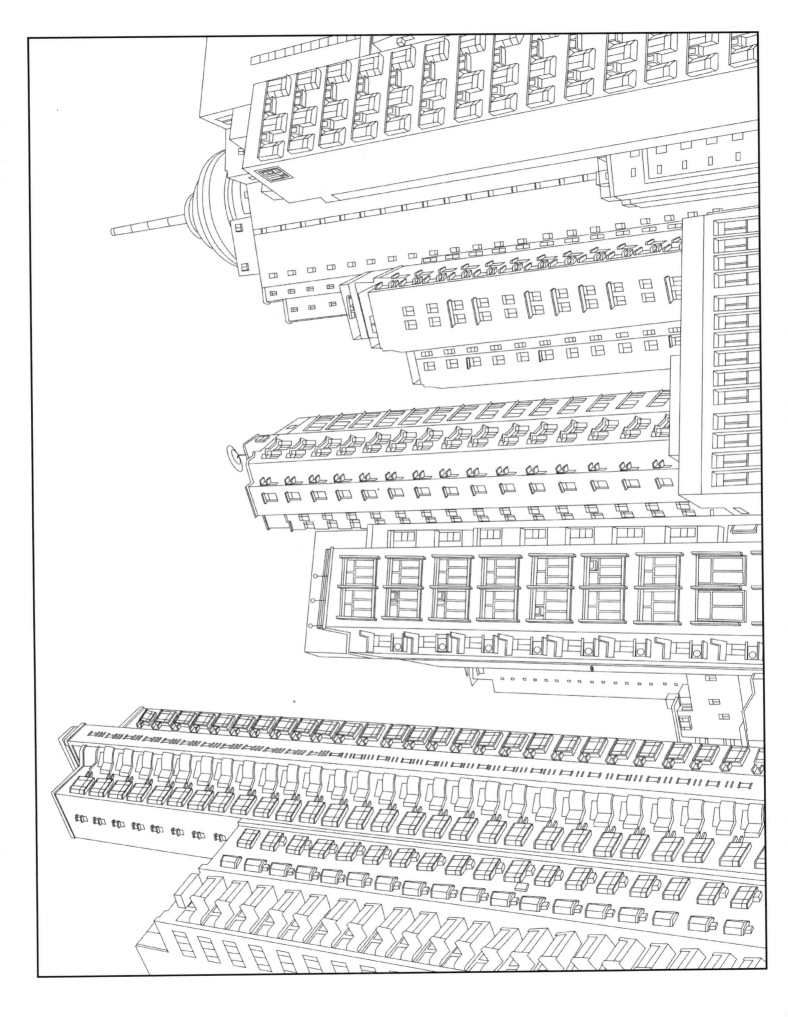

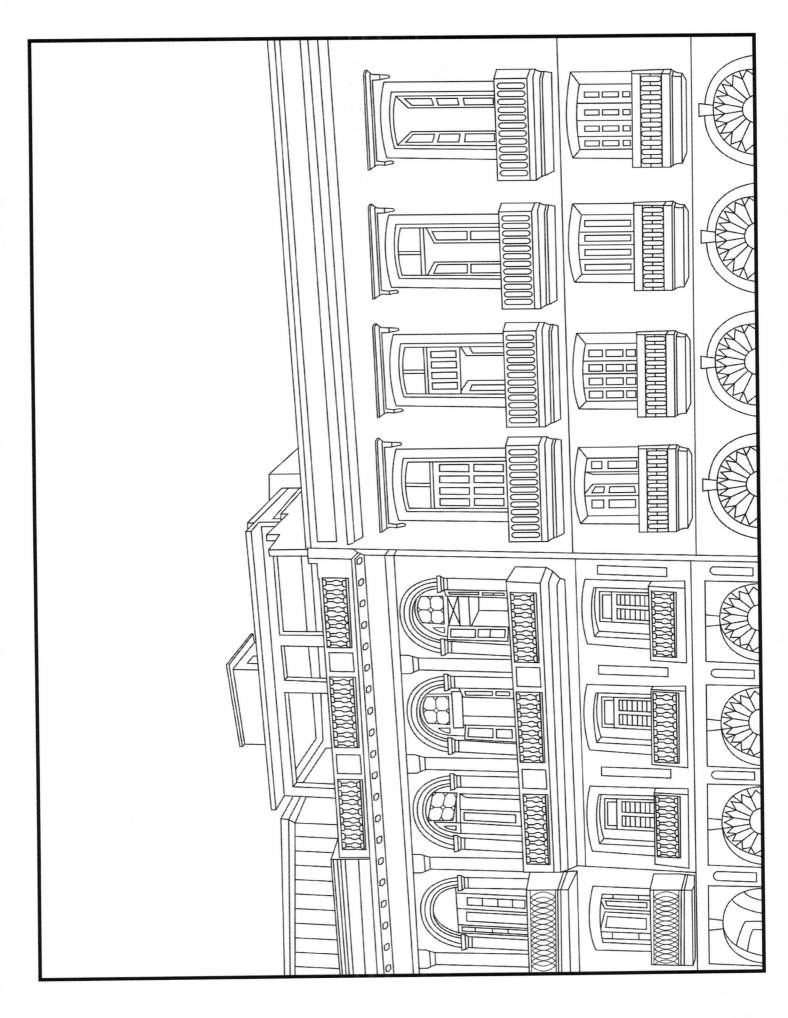

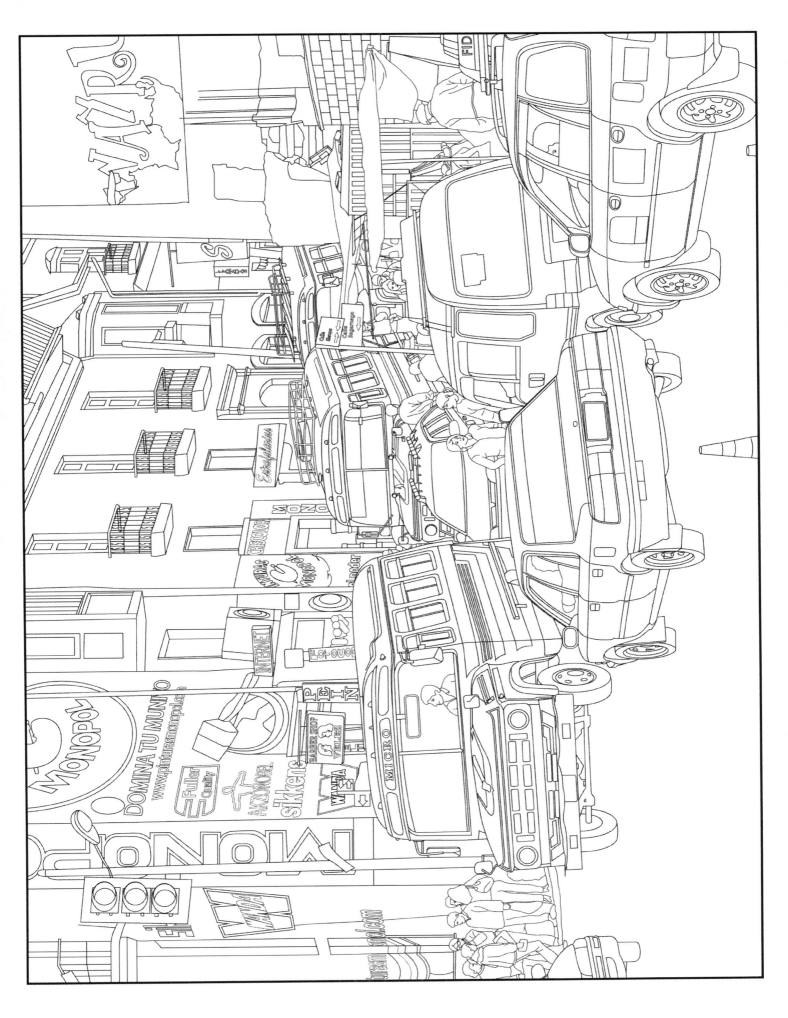

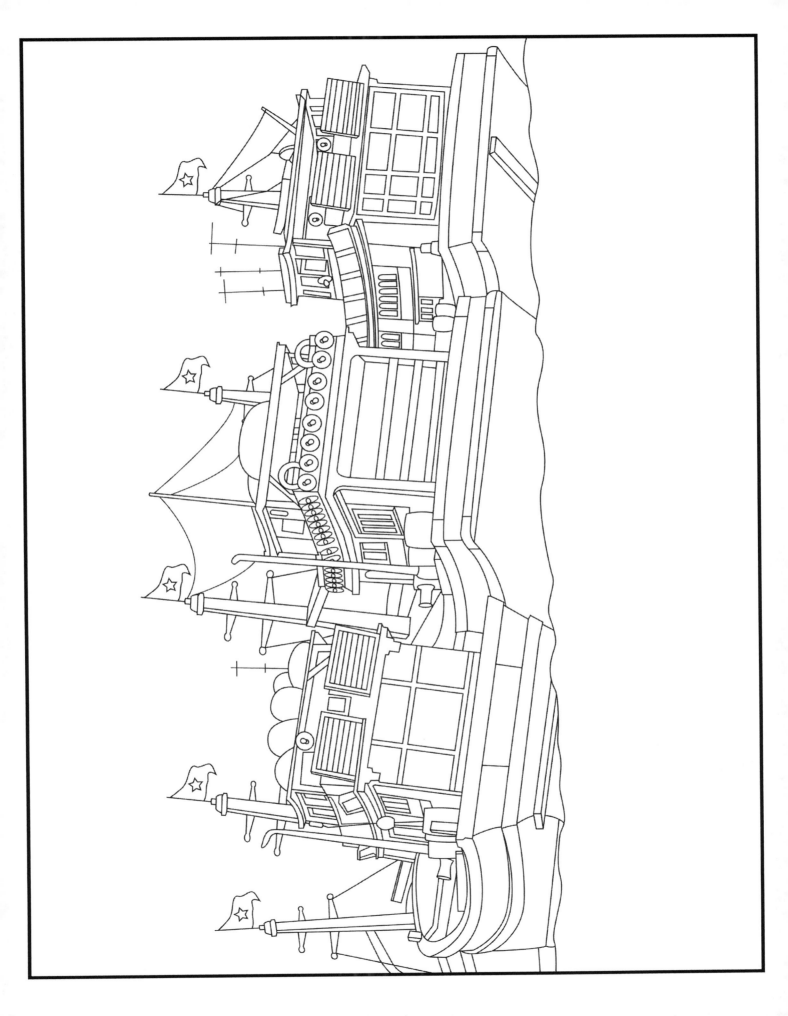

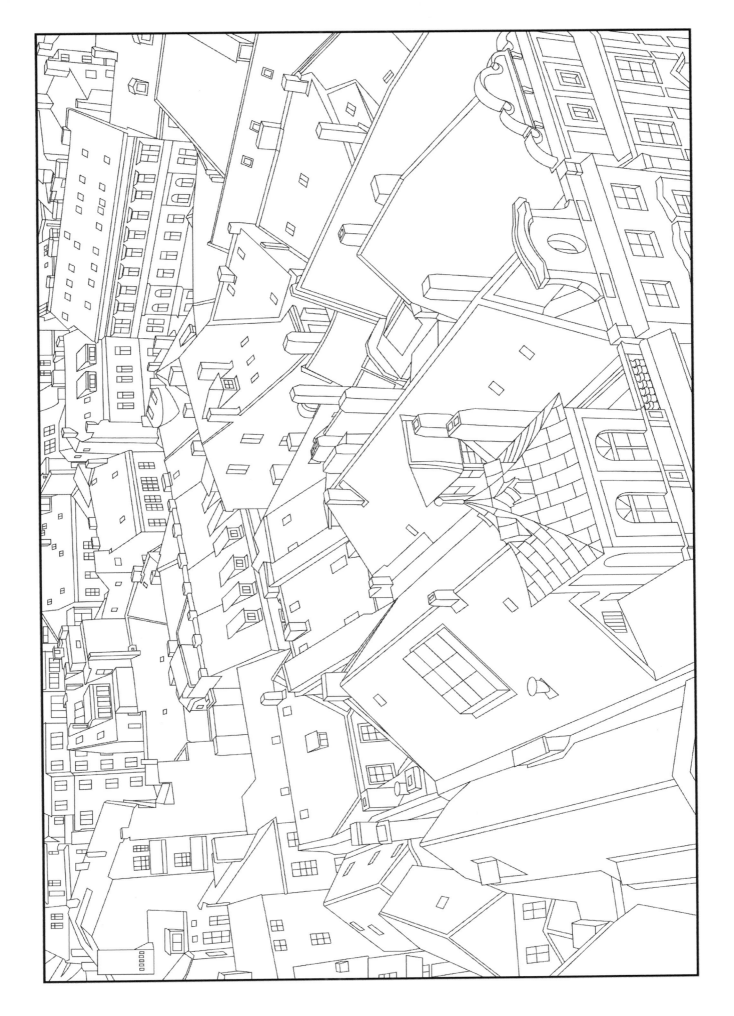

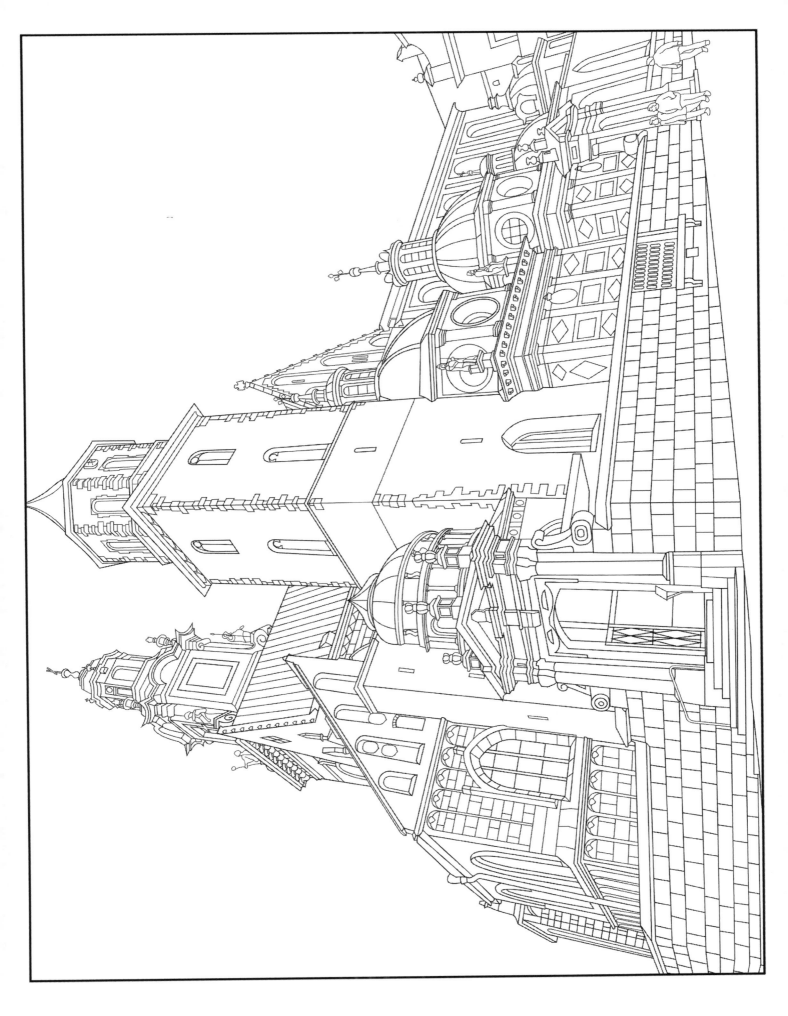

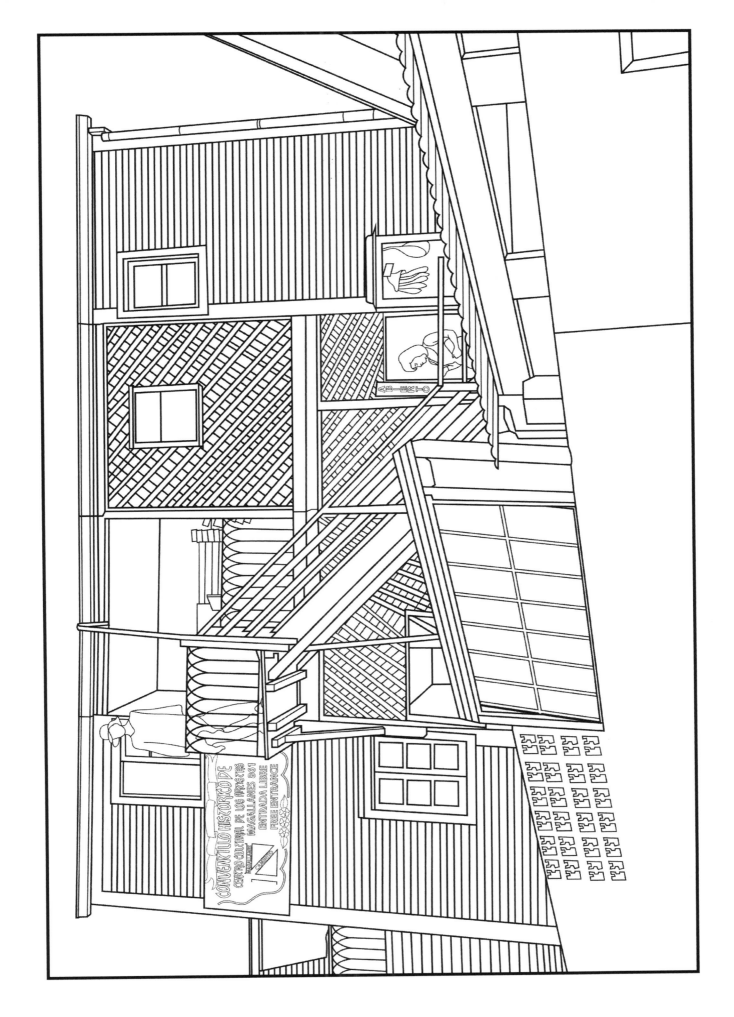

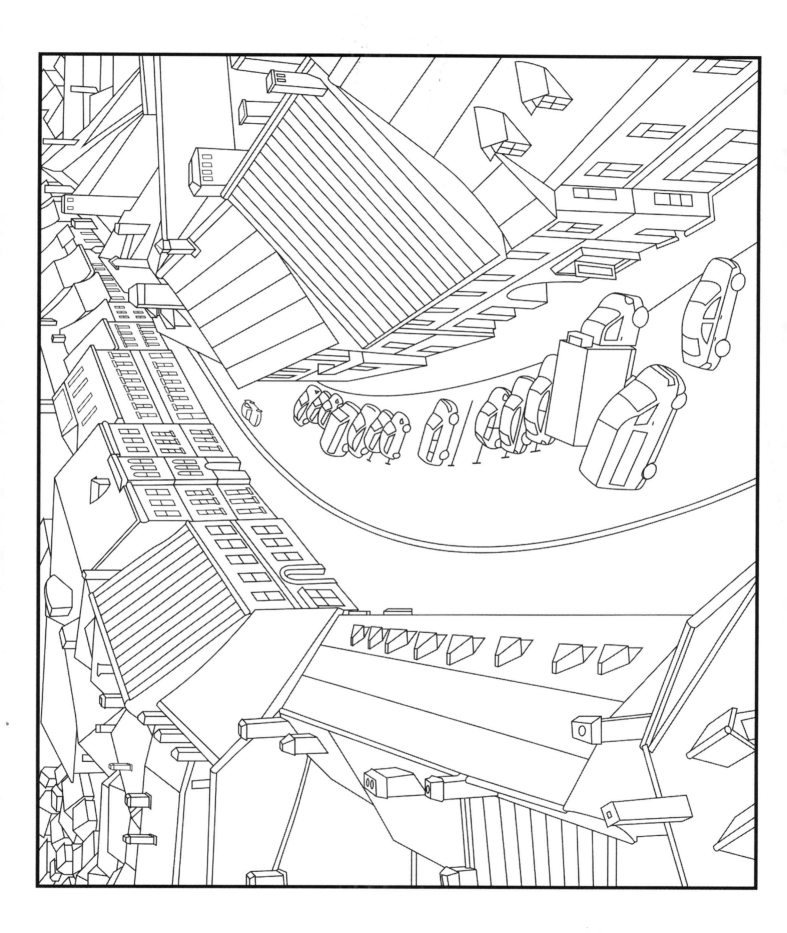

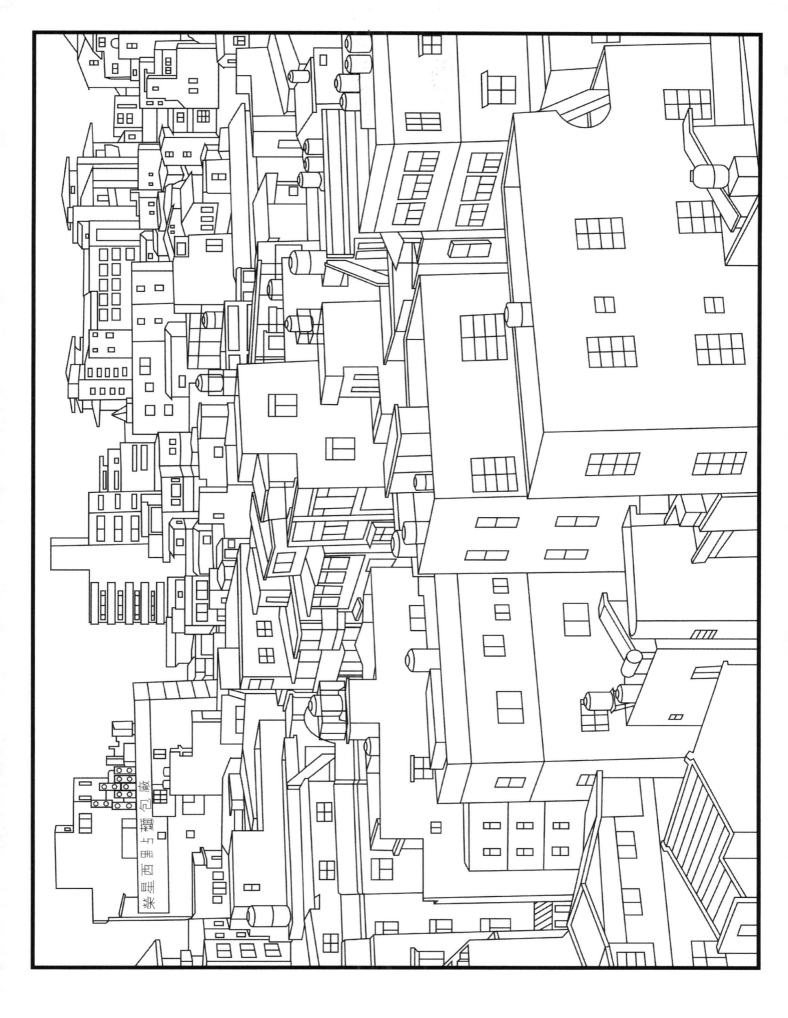

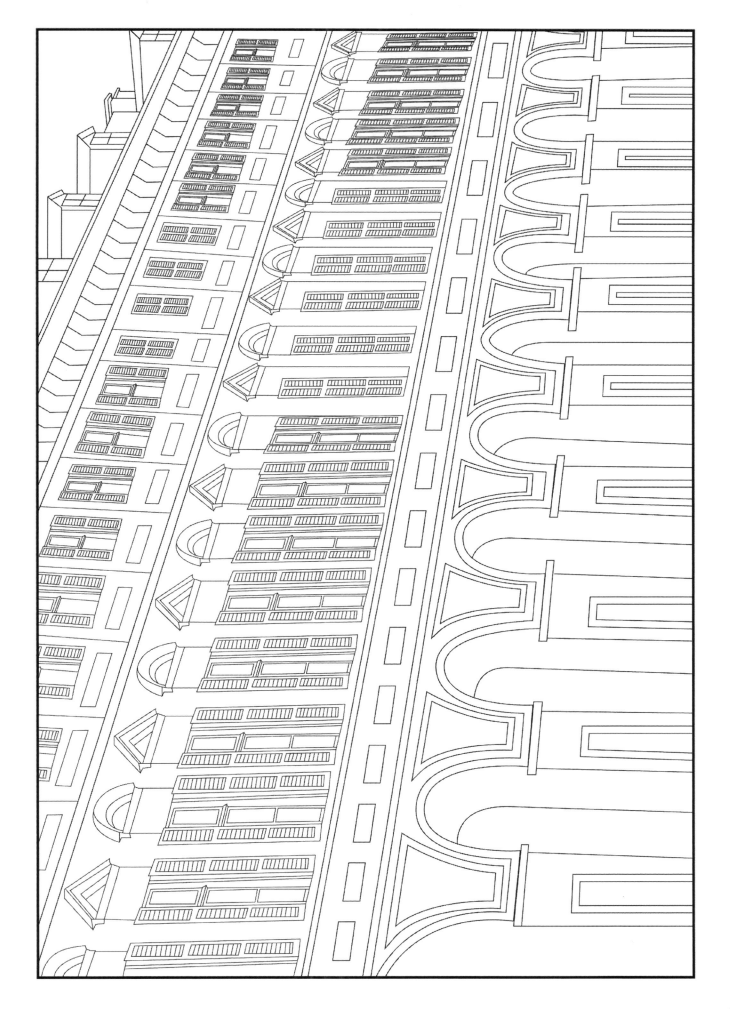

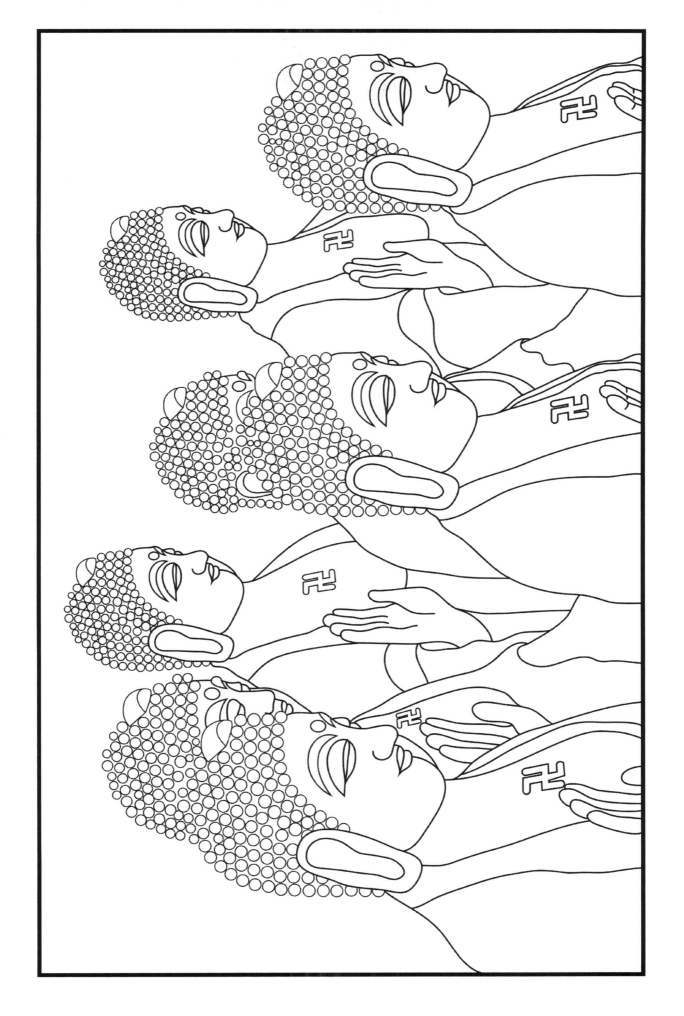

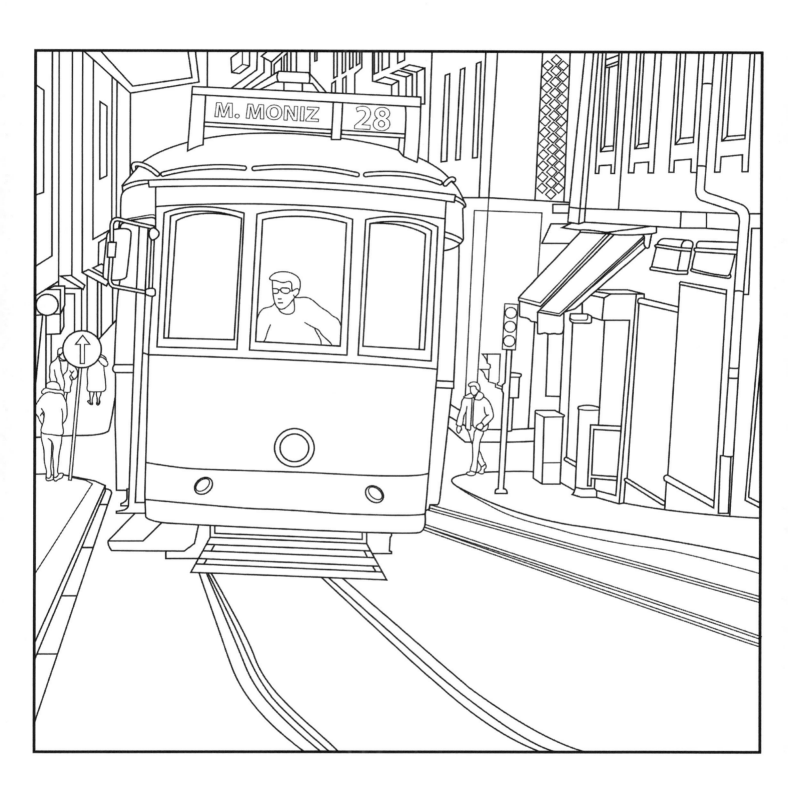

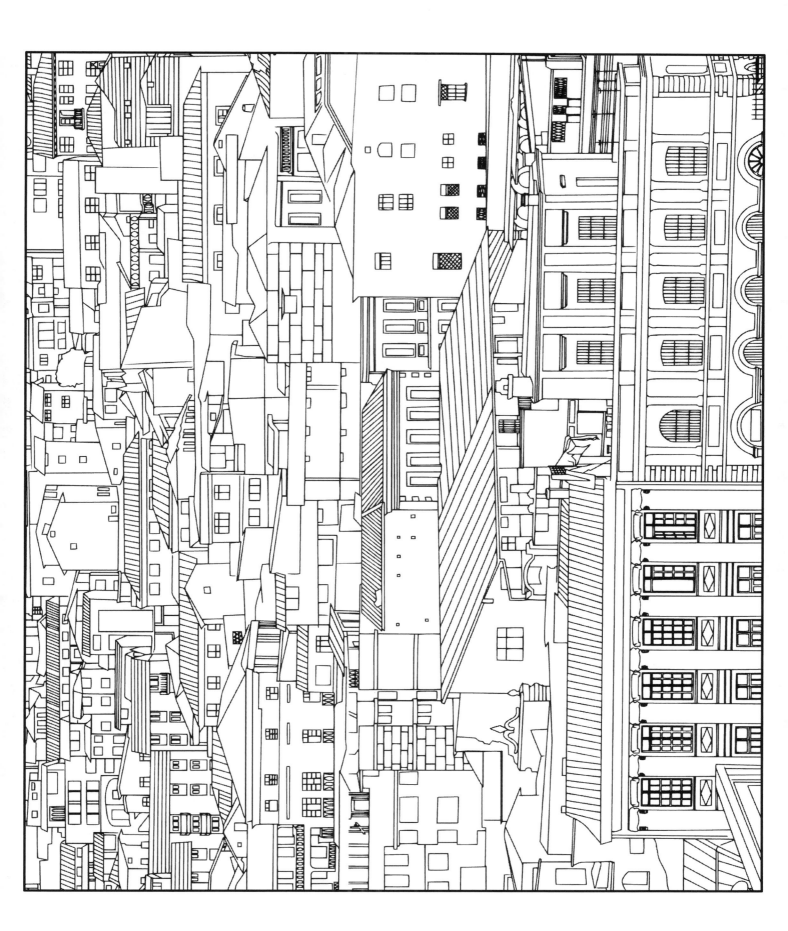

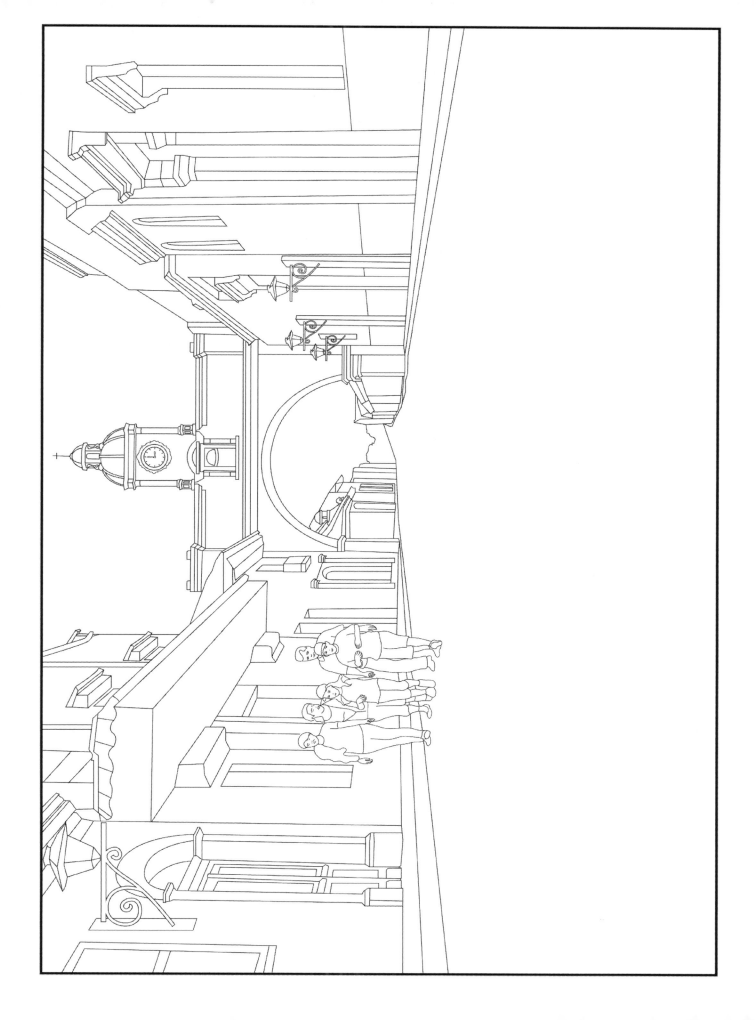

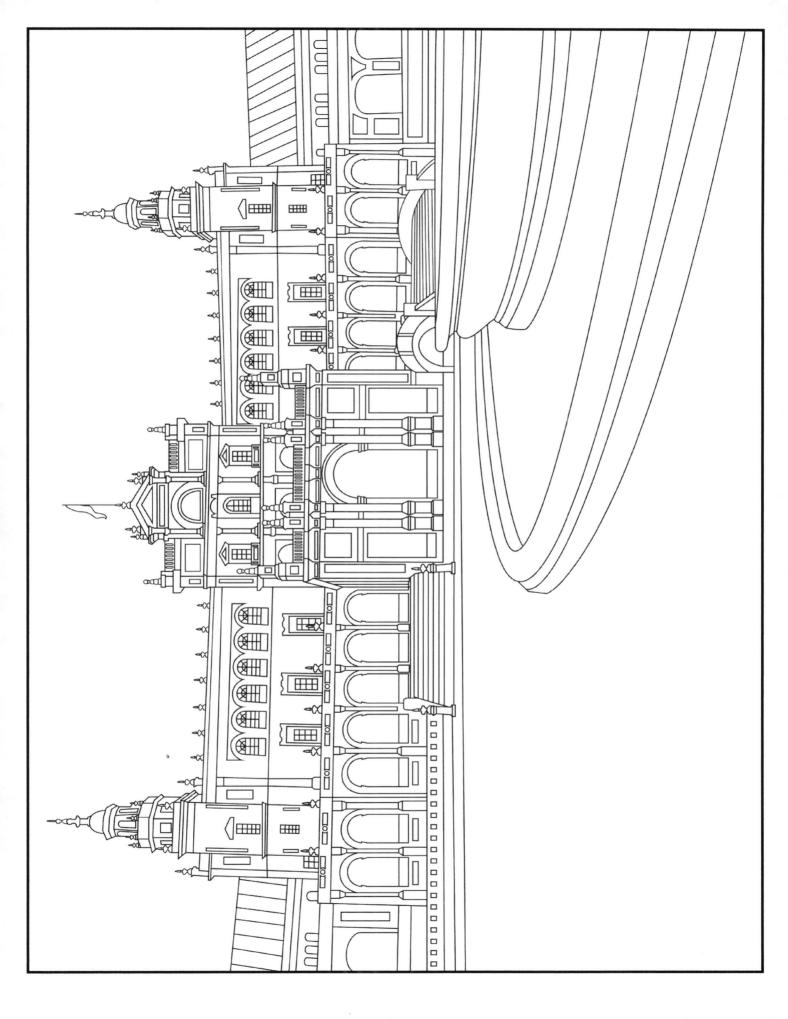

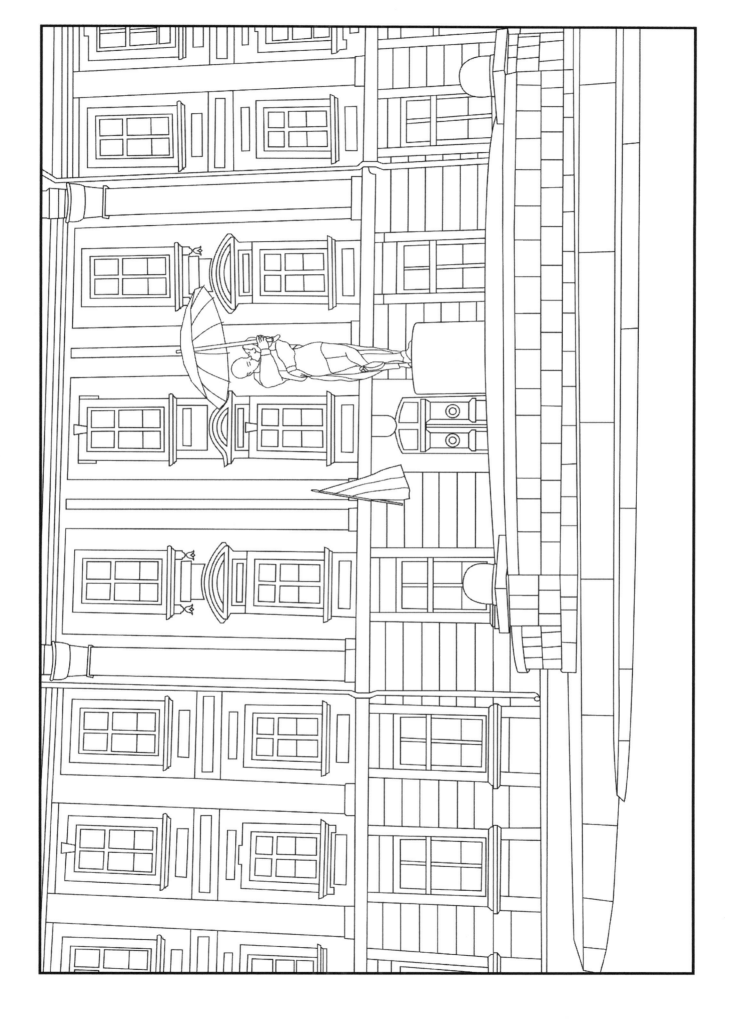

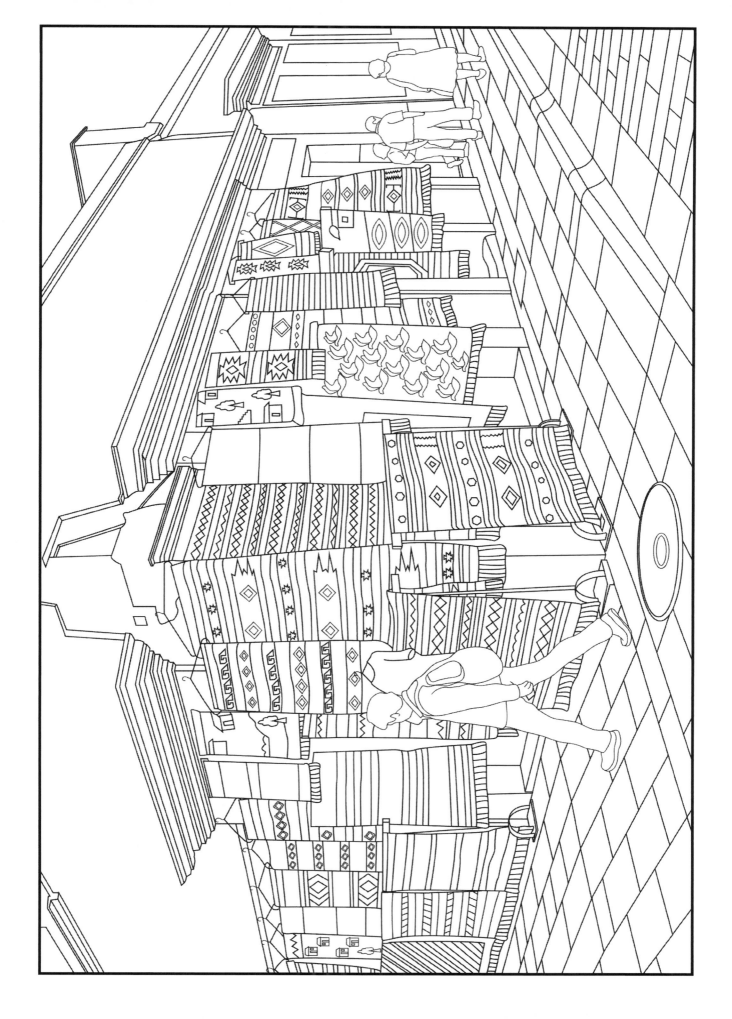

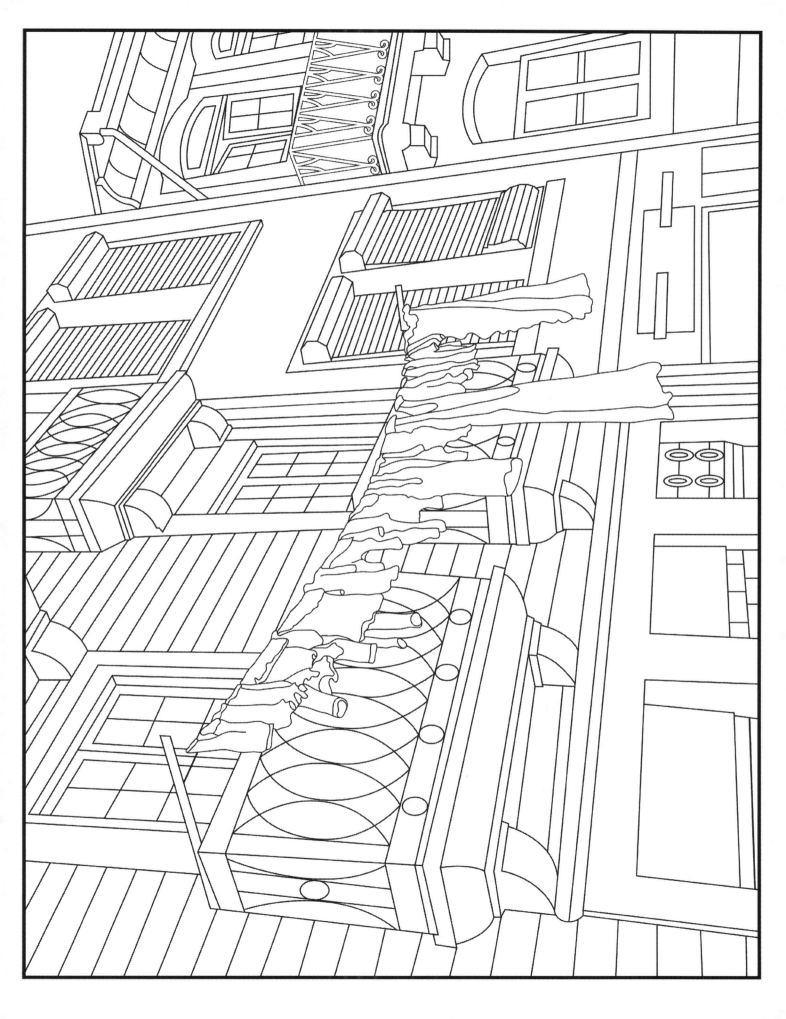

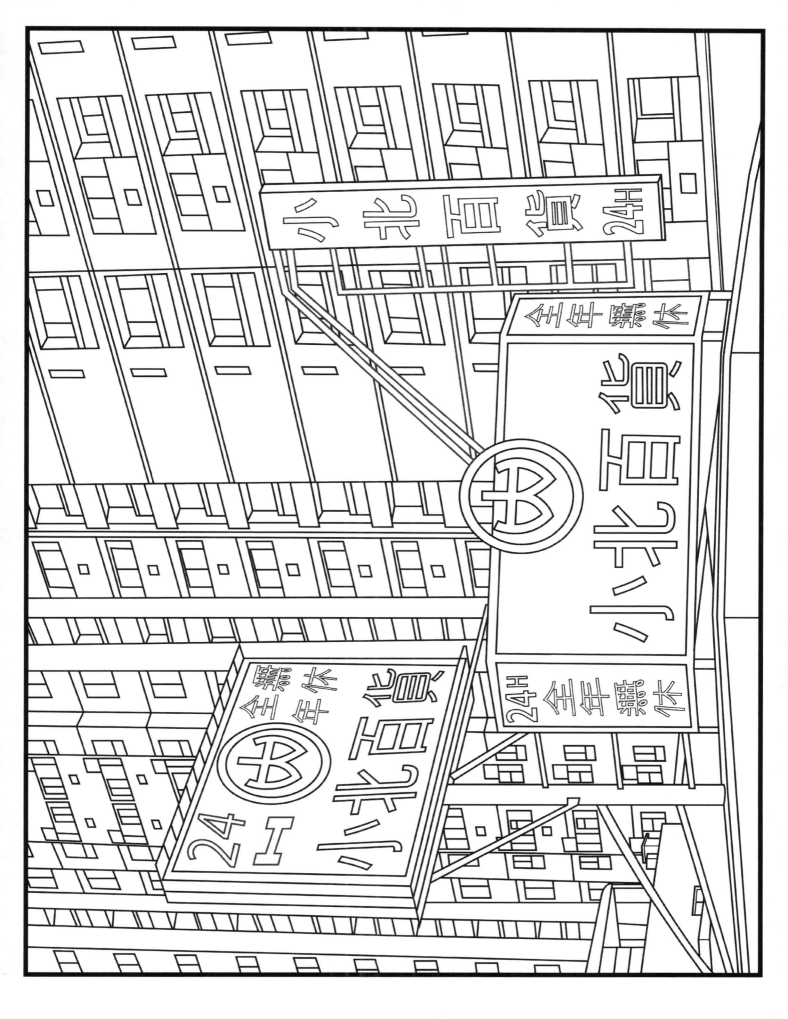

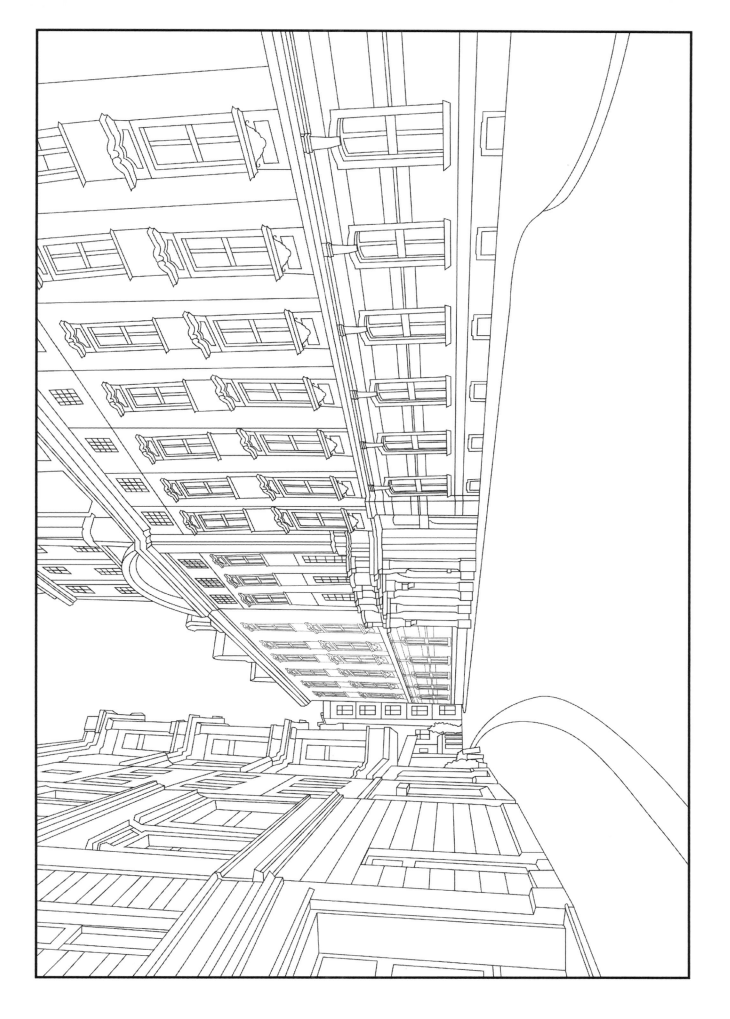

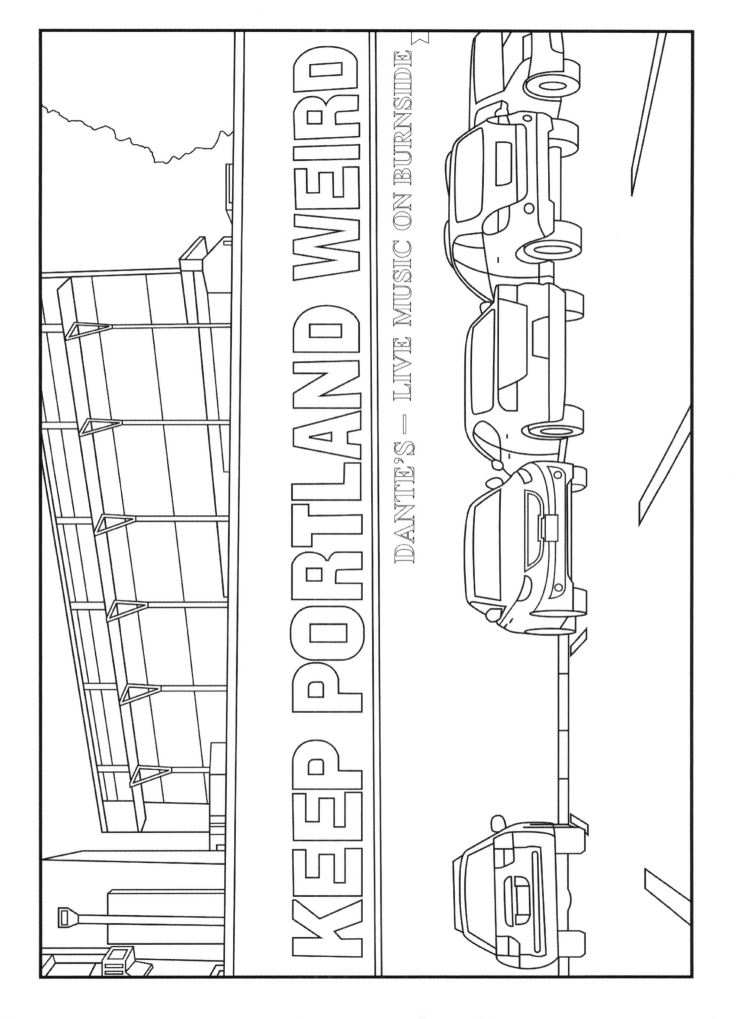

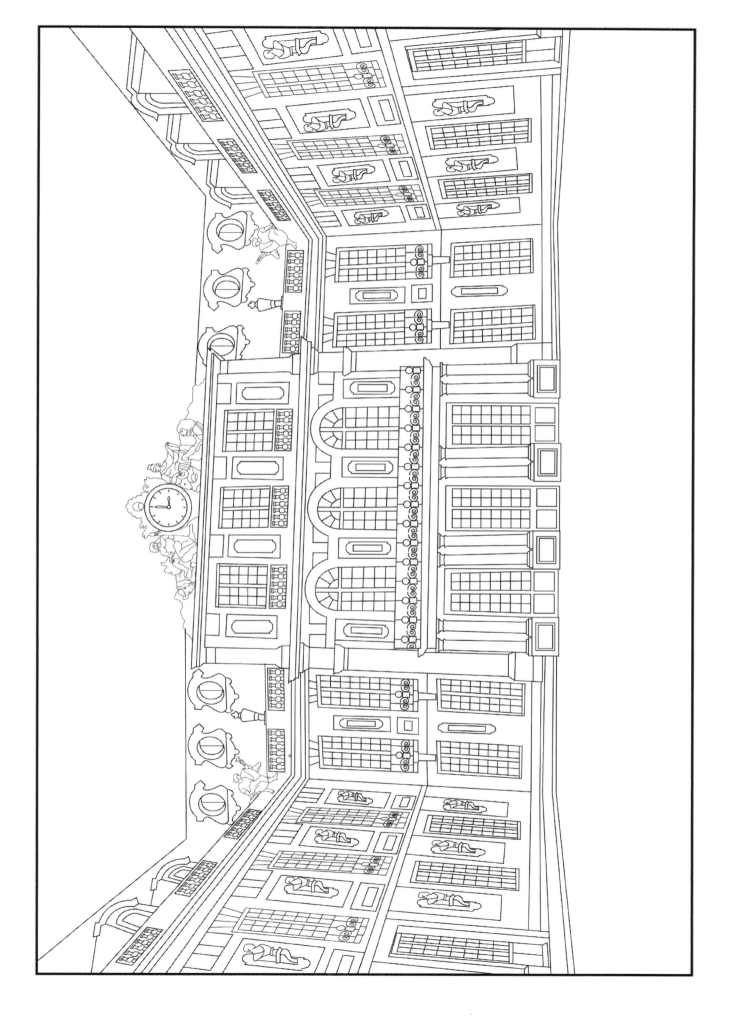

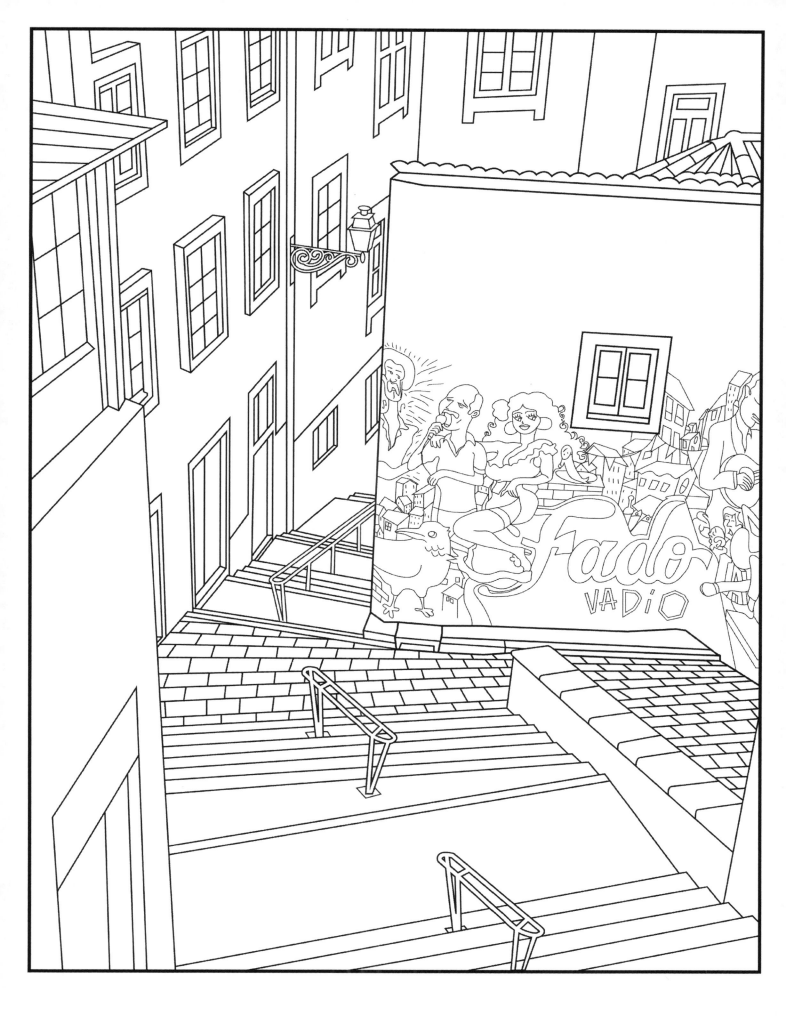

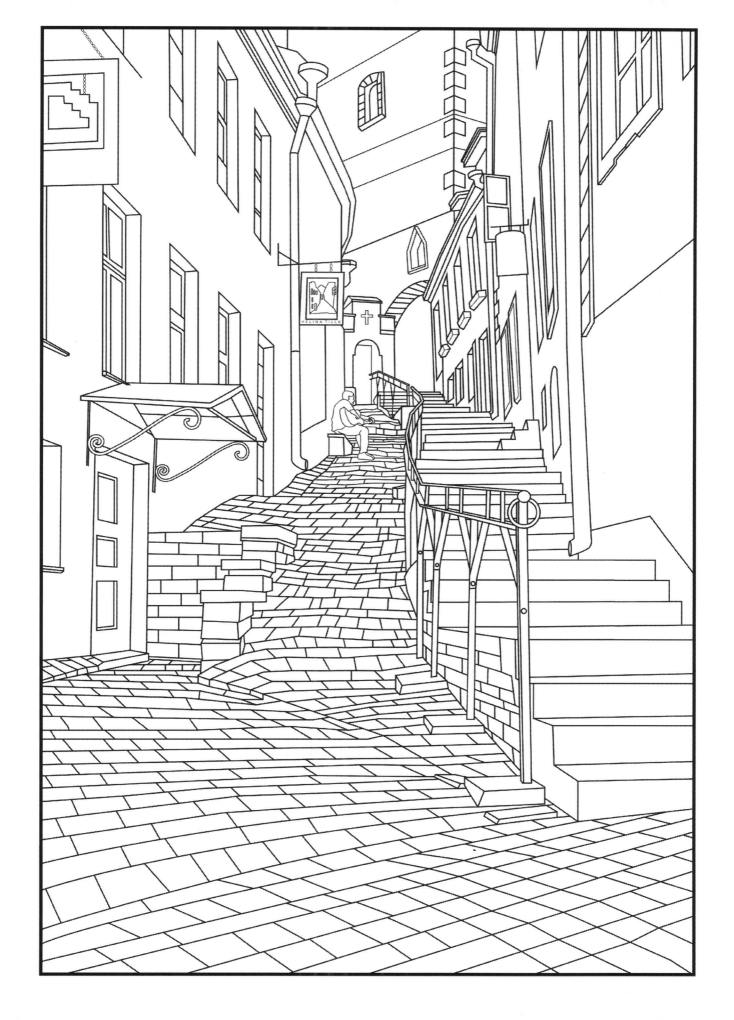

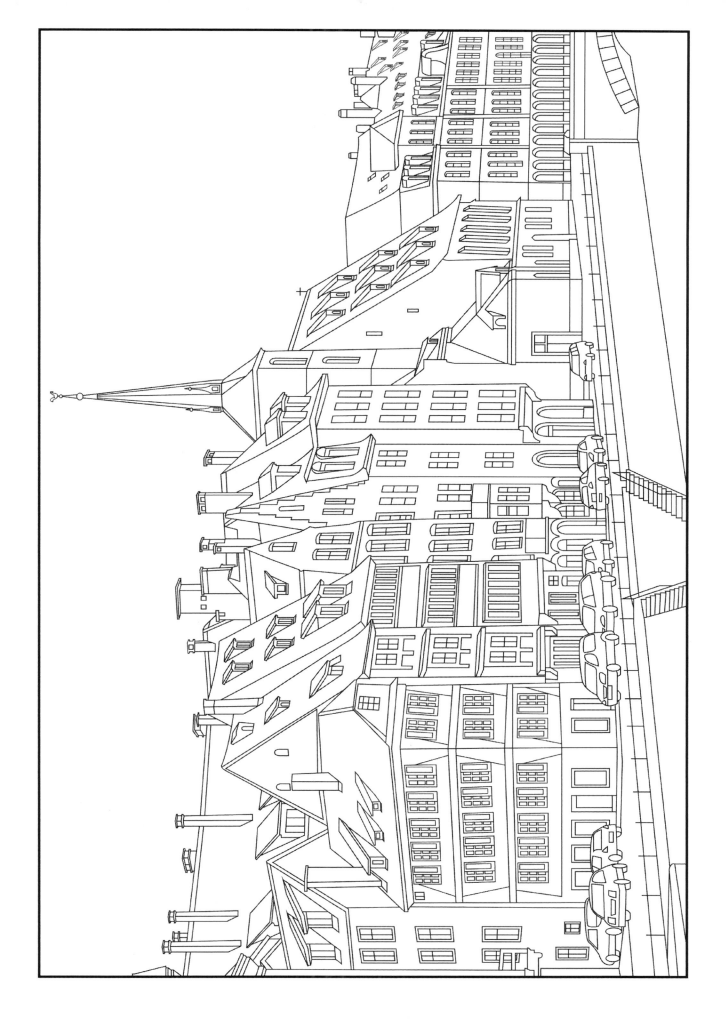

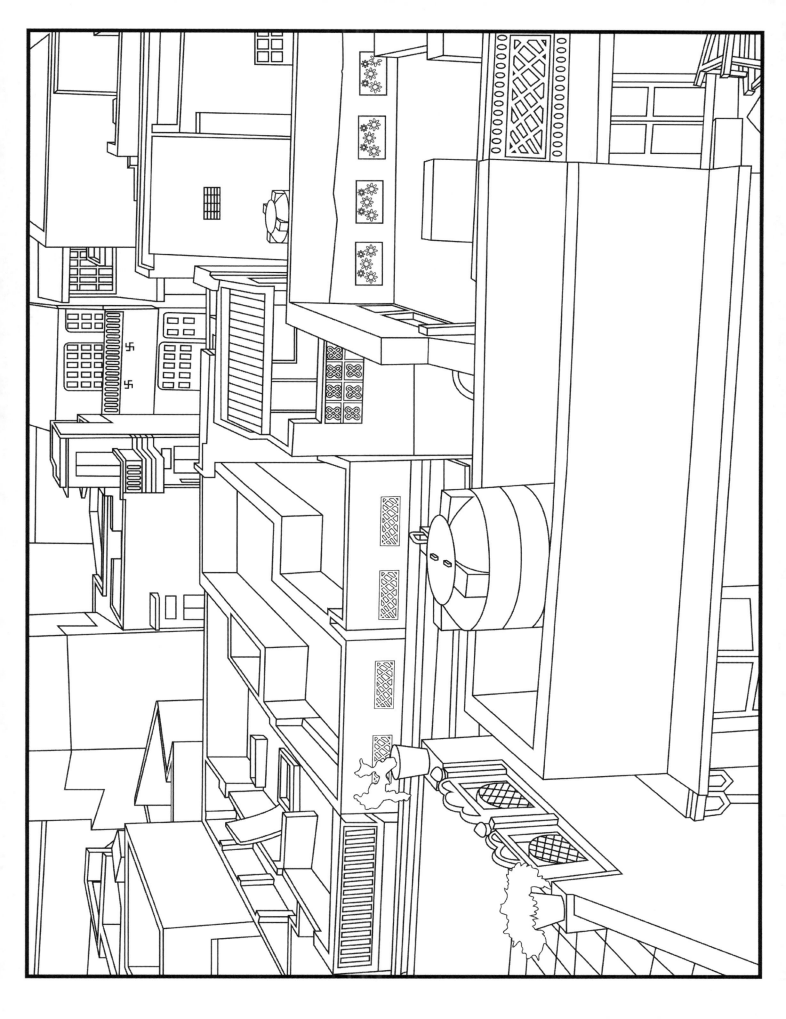

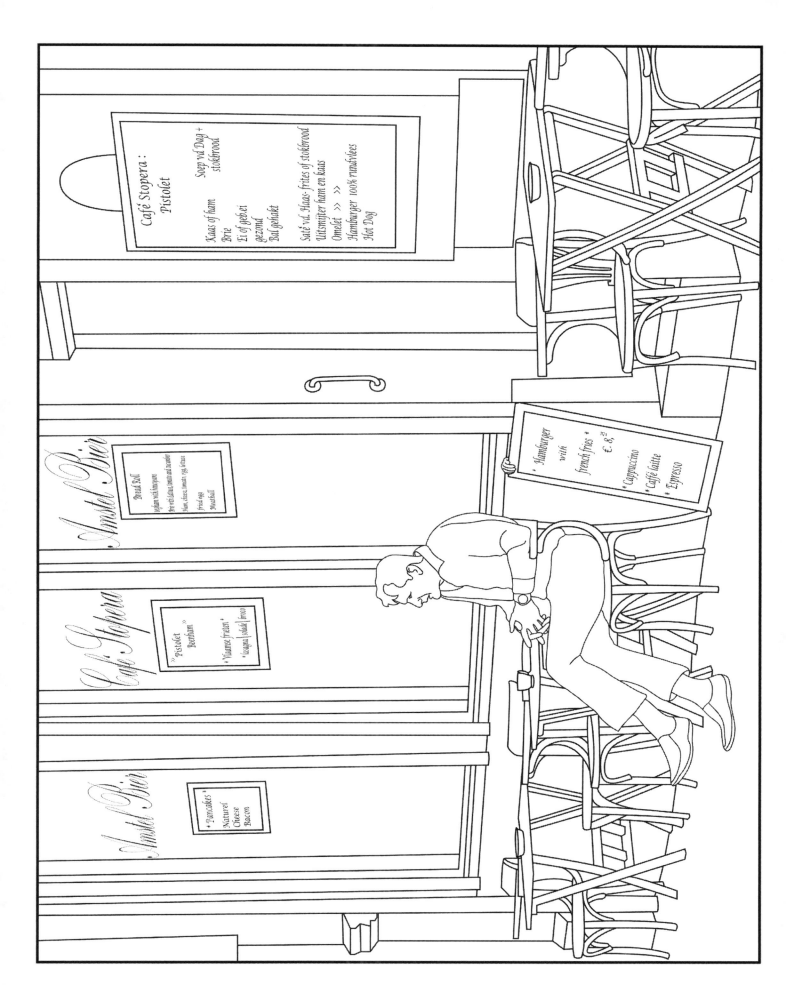

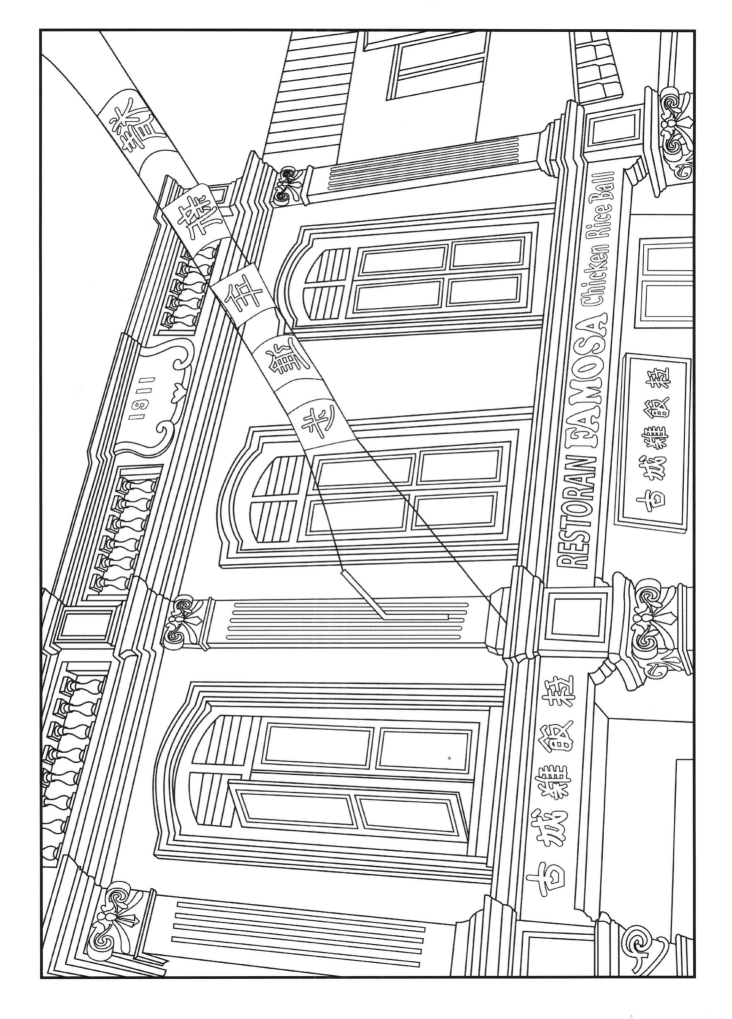

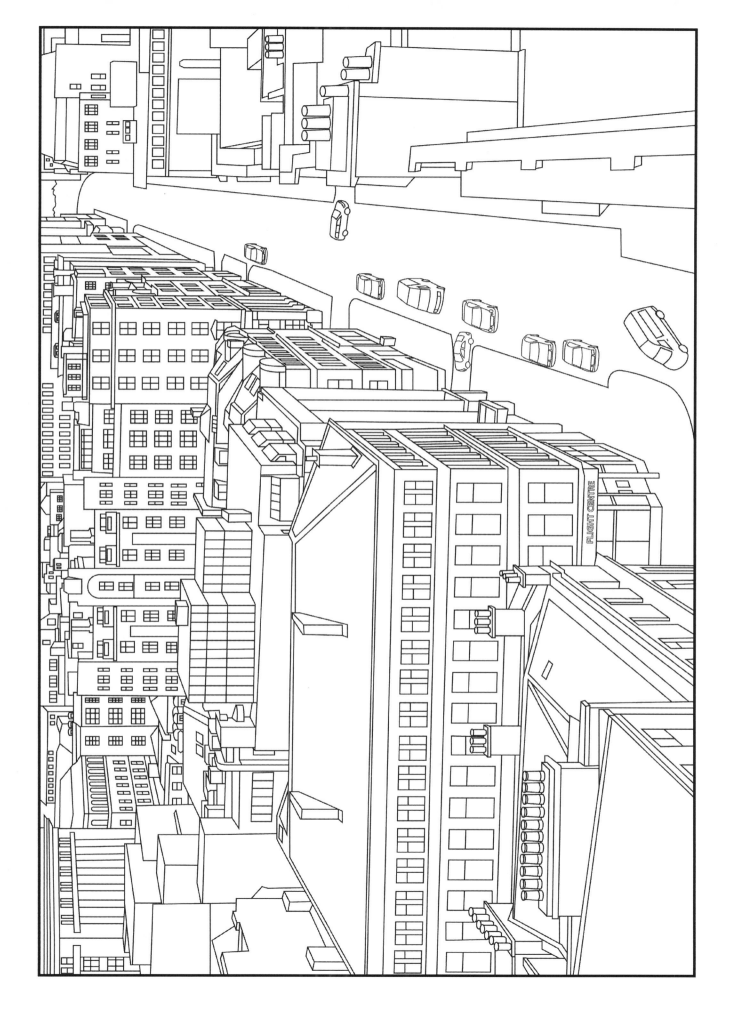

List of Illustrations

9. *View of Lisbon, Portugal, from the Castle of São Jorge* – Lisbon must be one of the most colorful cities in the world: azure sky and water, clay tile rooftops, colorful edifices and intricate azulejos tiles dot the city. We fell hard for Lisbon.

11. *Museo Conventillo Marjan Grum, Buenos Aires, Argentina* – In La Boca, everywhere we walked was full of color and detail, including this converted 1880s tenement that today showcases art and a personal story of immigration.

13. *A Street Corner in Cartagena, Colombia* – We awoke early one morning, wandering into this Caribbean city's colorful old quarter to eat fresh fruit from street vendors, and explore the colonial streets in solitude.

15. *The Eiffel Tower in Paris, France* – As we walked away from the Eiffel Tower, the buzz of a thousand tourists quieted, and we imagined what it'd be like to live in the shadow of a monument.

17. *An Aerial View of Riga, Latvia* – We fell in love with two different sides of Riga. Its youthful energy drew us in and kept us late at the bars and restaurants. Its collection of art nouveau architecture impressed during the day, making us think of colorful buttercream birthday cakes.

19. *A Building in Shandong Province, China* – In China, we couldn't stop looking up, marvelling at buildings like this: colorful symbols, ornate details, and Chinese characters offering messages of peace and harmony.

21. *A Quiet Street in Barichara, Colombia* – Bougainvillea cascade from brightly-colored balconies, and jewel-tone buildings are set against a blue sky and narrow stone streets. Tiny Barichara is, in a word, lovely.

23. *Liberty Bridge, Budapest, Hungary* – We woke up early to visit Budapest's famous indoor Gellért Baths, snapping this photo of a brightly-colored tram crossing over the Danube.

25. *At the Summit of Mount Tai, China* – Mount Tai has been a place of pilgrimage since 1,000 BCE, associated with birth and renewal for millions. After fighting through massive crowds and persistent vendors, and then riding to the holy summit in a cable car, we felt anything but renewed.

27. *View of Granada, Spain, from the Alhambra de Granada* – We arrived early, before the Alhambra opened and before the crowds arrived, to watch the sun rise above the Pomegranate City: a golden glow on a cool February morning.

29. *Chinese Lanterns on Cijin Island, Kaohsiung, Taiwan* – Seeking joy and good fortune at Tianhou Temple, we stopped for a break under a colorful ceiling of lanterns.

31. *Old Town Alley, Vilnius, Lithuania* – With one of the largest old towns in Europe, Vilnius is filled with beautifully-restored Baroque buildings and fascinating street art, such as mosaic tiles artfully embedded into a low-rise wall.

33. *República de la Boca Graffiti, Buenos Aires, Argentina* – La Boca's history is as colorful as its buildings, briefly seceding from Argentina in the late-1800s to create República de La Boca, and serving as a base for Argentine socialists over the years.

35. *A Temple on Xiao Liu Qiu Island, Taiwan* – We spent the day driving our scooters around the island, stopping at 38 temples and watching sea turtles bathe on coral reefs.

37. *The Rooftops and Bay of Kotor, Montenegro* – Kotor feels like a quickly unravelling secret: a place you can still get lost in marbled alleys and explore centuries-old fortifications on the edge of the cool blue Adriatic.

39. *Gingerbread Buildings in Strasbourg, France* – With winding, cobbled alleys and multi-color, timbered buildings, Strasbourg evokes thoughts of gingerbread houses, evil queens and fairy tale endings.

41. *The Brandenburg Gate in Berlin, Germany* – A symbol of Europe's struggles and re-unification, seeing the Brandenburg Gate as Europe teeters today on the brink of crisis was a reminder: that which we think is permanent can in fact be quite fragile.

43. *Skyscrapers in Hong Kong* – We found ourselves unexpectedly in Hong Kong, after a visa mistake left us with 24 hours to leave Taiwan. Wandering through a forest of skyscrapers, we craned our necks and lost all perspective, looking up at colorful concrete and wondering what it's like to live in a metropolis in the sky.

45. *The Tops of Historic Buildings in Havana, Cuba* – We imagined the Havana of Hemingway, drinking sundowners and indulging in cigars, before driving a rental across an island forgotten by time, passing donkey carts in tiny towns.

47. *A Street Scene in La Paz, Bolivia* – At 11,913 feet (3,631 meters) above sea level, this colorful sea of urban madness left us quite literally breathless, with plenty of time to snap photos as we paused to catch our breath.

49. *Boats on the Mekong Delta, Vietnam* – Sitting on the top deck of a rusty but colorful boat, we sipped on cans of Vietnamese beer, passing fishing boats near Can Tho as we traveled from the south of Vietnam to the capital of Cambodia.

51. *Prague's Old Town* – From the top of Prague's Old Town Hall Tower, we were treated to 360° views of the city's famously beautiful buildings, exploring the City of Spires as birds might.

53. *Wawel Royal Castle in Kraków, Poland* – Once the home of Polish kings and queens, and before that a fierce dragon, it's easy to let your imagination run wild when staring at the spires and domes of this Royal Castle.

55. *A Colorful House in La Boca, Buenos Aires, Argentina* – Buenos Aires' most colorful barrio, Italian immigrants used leftover scrap metal and marine paint to build their homes in the 1800s, forming the basis for the rainbow neighborhood that is La Boca today.

57. *An Aerial View of Sibiu, Romania* – We spent a month in Romania, wandering through sleepy Transylvanian cities like Sibiu, crossing the border to Moldova, and traversing the country until we hit Serbia.

59. *The Colorful Buildings of Cijin Island, Kaohsiung, Taiwan* – We took a ferry to this man-made island, enjoying the beach, and visiting the temples. Because this is Taiwan, we also ate soft-serve chocolate ice cream, served to look like poop in a squat toilet!

61. *A Building Detail in Milan, Italy* – Walking past this grand old building in Milan, we were briefly tempted to trade our lives as travelers for those of fashionistas. Instead, we snapped a photo and hopped a train to Germany.

63. *Buddha Statues, Fo Guang Shan Monastery, Taiwan* – We slept at the monastery and awoke before sunrise, standing among dozens of meditating Buddhas as the sun signalled the beginning of a new day.

65. *Tram 28 in Lisbon, Portugal* – Lisbon's famous Tram 28 is a monument on wheels, passing the city's most notable attractions as it navigates a loop through Lisbon's colorful historic heart.

67. *An Aerial View of Quito, Ecuador* – A narrow strip of life nestled in a valley of mountains and volcanoes, Quito is enchanting. From up above, the colonial buildings transform into colorful squares, and the city becomes silent but for the sounds of new friends.

69. *The Santa Catalina Arch in Antigua, Guatemala* – The quintessential symbol of Antigua, we passed by the 17th century arch at least once a day, crouching low to find a new and interesting angle to consider the city's most-recognized monument.

71. *Plaza de España in Seville, Spain* – We dream of returning to Seville, if only to drink cañas outside tapas bars, stuff our faces with jamón ibérico, and snap photos of the city's colorful Moorish-European architecture.

73. *Kissing Students Statue and City Hall, Tartu, Estonia* – A mirror of modern Estonia, the statue hints at the spontaneity, youth and energy of this digitally-savvy country, set against a colorful backdrop of classic European architecture.

75. *Street Corner in Oaxaca de Juárez, Mexico* – A culinary and cultural heart of Mexico, Oaxaca bursts with everyday color: low-rise, colonial buildings, handicrafts and textiles from the local indigenous groups, and what feels like a non-stop fiesta.

77. *Laundry Drying in Porto, Portugal* – Laundry dries with the help of sunshine and a fresh breeze from the Douro river.

79. *A 24-Hour Store in Kaohsiung, Taiwan* – Taiwanese cities assault the senses, and seem to pack in as much visual stimulus per-square-inch as humanly possible.

81. *An Empty Street in Wrocław, Poland* – The first rule of visiting Wrocław, is learning how to pronounce Wrocław: vrat-swaf (more or less).

83. *The Keep Portland Weird Sign, Portland, Oregon, USA* – We waited in line for more than an hour at Voodoo Doughnuts before savoring a maple bacon, and leaving a little more weird.

85. *The Ornate Palace of Versailles, France* – When we saw the extravagant metals, jewels, art and tapestries of Versailles first-hand, our first thought was, "no wonder there was a revolution."

87. *Graffiti in Lisbon, Portugal* – We spent a night drinking Portuguese red, listening to the raw, melancholic songs that have become the heart and soul of a city and nation: fado.

89. *Temple of the Golden Pavilion, Kyoto, Japan* – Imagining we'd reached optimum Zen, we walked through the gardens and admired Kinkaku-ji's dueling simplicity and splendour.

91. *A Midnight Stroll Through Tallinn, Estonia* – We befriended an Estonian man who insisted on taking us for beers. We ended up on an impromptu midnight tour, wandering through Tallinn's fairytale old town, hoping he wouldn't rob us (he didn't).

93. *The River and Buildings of Strasbourg, France* – We arrived in the self-proclaimed Capital of Christmas on December 24, awaking at midnight to the songs of centuries-old church bells; a private concert in the heart of Strasbourg's Grande Île.

95. *The Rooftops of Rajasthan State, India* – In Rajasthan, we retreated in the evenings to rooftops like these, ordering ice-cold Kingfisher beers, served in tea cups for discretion, to cool off after a day under the desert sun (Photo credit: Sarah Cobb, 2004 / used with permission).

97. *An Outdoor Café in Amsterdam, Netherlands* – Delirious with jet lag, we found brief respite on a quiet café terrace.

99. *A Restaurant in Melaka, Malaysia* – We visited Melaka at Chinese New Year, when this UNESCO city was dressed up in the brightest colors of the year.

101. *An Aerial of Glasgow, Scotland* – It was during the Haggis Pakora at Mr. Singh's India Restaurant that we realized the rough-and-tumble Glasgow of the past is gone, replaced by resourcefulness, exuberance, and an eclectic cultural mash-up built upon a centuries-old city.

Made in the USA
San Bernardino, CA
07 December 2016